MILLSTONES OF THE PENNINES AND NORTH WEST ENGLAND

David Johnson

AMBERLEY

In fond memory of my brother-in-law Andrew.

First published 2023

Amberley Publishing
The Hill, Stroud
Gloucestershire, GL5 4EP

www.amberley-books.com

Copyright © David Johnson, 2023

The right of David Johnson to be identified as
the Author of this work has been asserted in
accordance with the Copyrights, Designs and
Patents Act 1988.

ISBN 978 1 3981 1293 3 (print)
ISBN 978 1 3981 1294 0 (ebook)

British Library Cataloguing in Publication Data.
A catalogue record for this book is available from
the British Library.

Typesetting by SJmagic DESIGN SERVICES, India.
Printed in Great Britain.

Contents

Introduction

For as long as people have grown cereals as their basic food source, they have needed ways of grinding the grain into flour. The simplest way of doing this was with a *saddle quern*, known from the late Mesolithic on sites where people harvested natural cereals, and from archaeological excavations on Neolithic and later prehistoric periods. A handheld stone – the *rubber* – was rolled back and forth across a concave lower stone – the *bedstone* – to grind the grain into flour. In Iron Age Britain *rotary querns* largely replaced the saddle quern:

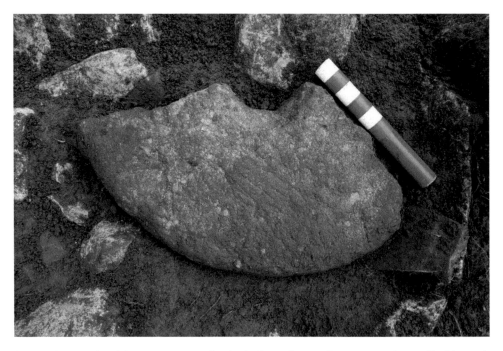

A quern fragment found during excavation of an Anglo-Saxon farmstead on the lower slopes of Ingleborough in 2018.

these had an upper *handstone* with a central hopper into which grain was poured and a slot for attaching a handle. This was turned, rotating the upper stone on the fixed base stone to grind the grain into flour. A later Iron Age technological development was the *beehive quern*, shaped as its name suggests, which was deeper and held more grain and was less onerous to operate. Some Roman-period querns or millstones were locally sourced, but lava querns were also imported to eastern England from the Rhineland; it is thought they were shipped across as ballast and were cheaper than, say, querns from the Peak District.

Excavation of a settlement complex on the flanks of Ingleborough in the Yorkshire Dales, in 2018, found two broken gritstone querns, one probably a Roman-period disc quern and the other either part of a Roman-period or early medieval hand quern or small millstone.

The Domesday Book, in 1086, recorded over 6,000 corn mills – water- or wind-powered – across England with on average one mill to every two manors, representing at least two millstones in each mill; larger mills had two pairs. By the year 1300, there could have been up to 13,000 mills across England. Manorial customs required all tenants to have their grain milled at the manorial *soke* mill; a proportion of each tenant's grain or flour was taken as *mulcture*, a toll to which millers were entitled by manor court rulings.

Millstones and Grindstones

Similar to millstones were grindstones and edge runners. A *millstone* is one of a pair of large circular stones used for grinding corn in a mill, whereas a grindstone is a large stone disc used for grinding, sharpening or polishing. *Grindstones* and *edge runners* were operated in the vertical plane as opposed to millstones' horizontal, with the edge of a single stone being the critical part: it did the grinding or crushing alone whereas millstones worked in pairs. The lower stone – the *bedstone* – was fixed while the upper stone – the *runner* – rotated under water or wind power. The two milling faces had grooves (*furrows*) cut into them, separated by flat *lands* and smaller grooves (*feathers*). For the pair to work well it was vital to maintain the correct spacing relationship between the two stones, a process known as *tentering*, and furrows and feathers had to kept in good order by regularly maintaining them, which involved the *millwright dressing* the furrows and feathers with a pick (a *mill bill*) and chisel. Grindstones and edge runners were used for crushing ore or flint; reducing sandstone to sand; shredding oak bark in tanneries; pulping wood for papermaking; pulverising fruits (e.g. apples for cider) or nuts in oilmills; crushing gorse (whins), especially in Scotland's Central belt; crushing bone and coprolites for fertiliser and rape for winter fodder; and making gunpowder. They had other minor uses as well. For example, a plea lodged by

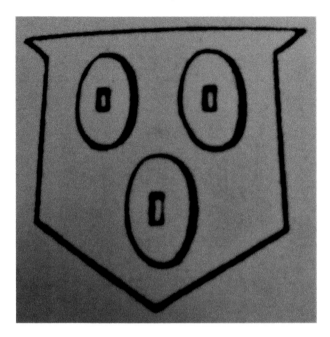

The coat of arms of the Millington family, showing three millstones each with a central eye.

William Eure at Whitby (North Yorkshire) in 1464 complained of the theft of a ship belonging to him containing 'a pair of millstones for making mustard called mustard-querns'.

A rare reference to the importance of millstones can be seen in the Millington family of Millington, near Altrincham (Cheshire): the importance of corn milling to the family, and possibly their medieval origins, was perpetuated in the family and village name by their coat of arms, which included three millstones complete with central eye.

The Geology of Millstones

Most millstones in Britain were made from Millstone Grit – coarse sandstone with variable proportions of quartz. Millstone Grit weathers over time to a dull grey, and for this reason millstones sourced from it were often referred to as 'grey stones'. This was not the only suitable rock type, however. As long as the source rock was hard, coarse and flawless, it was worked for making millstones or grindstones. Thus, in Ayrshire, in south-east Anglesey, at Penallt (Mons.) and in Co. Donegal, a quartz-sandstone conglomerate was worked; in eastern Cumbria, Penrith Sandstone was used; also in Cumbria, Shap Granite and Eskdale Granite were preferred; at various sites in Scotland, granite, basalt and schists were used; and in the Wye Valley and Forest of Dean, Old Red and Upper Pennant Sandstone were worked. Some specialist edge-runner grindstones were hewn from Carboniferous Limestone in south-east Cumbria.

A grindstone roughout found in a production site on Blaze Fell in the Eden Valley of Cumbria.

Imports of millstones, especially to south-eastern areas, are recorded through history. It was often more cost-effective to ship them down rivers and across the Channel rather than to rely on slow and often impassable roads. Thus, millstones of blue (or black) Rhenish lava were sourced from the Rhine from late medieval times for milling wheat; many were quarried at Mayen, west of Koblenz, and shipped down the Rhine through Cologne (Köln in German), and in England this name was corrupted to *cullen* for these millstones.

Cullen stones and grey stones were overwhelmingly *monolithic*, carved and shaped as one complete stone. Again from late medieval times, *burrstones* were imported from France, for milling wheat, though until the late eighteenth century numbers remained small. Burrstones were not monolithic but composed of segments held together by a cast-iron hoop. Individual segments were imported and put together in up to thirty factories in British ports and cities. Burrstone was quarried from coarse sandstone beds containing a high proportion of quartz from a number of quarries around La Ferté-sous-Jouarre, east of Paris. The segments were despatched by barge down the Rivers Marne and Seine before transhipment across the Channel. It has been suggested that they were – initially perhaps – brought over as ballast in ships that would otherwise have returned empty.

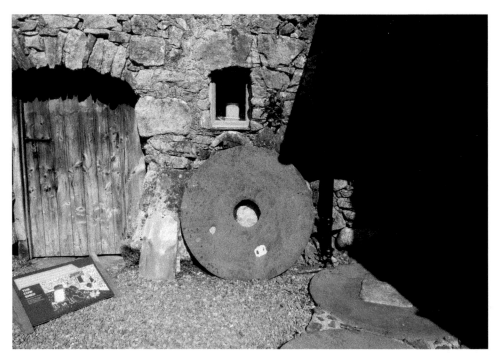

A worn-out German 'bluestone' outside Eskdale Mill in Boot. This is probably one of a pair purchased *c.* 1753.

A 1.2-metre-diameter French burrstone outside Bainbridge Low Mill, Wensleydale. The iron band round the circumference and the ironwork within the eye are visible.

Production Sites

It is generally accepted that the Peak District was by far the most important focus of production, and one list of relevant publications by region asserted the Peak District was one of England's two main centres in the modern period, along with Northumberland. The industry in Northumberland has been published with one source noting forty production sites in the county.

Production in the Peak District is recorded from the mid-thirteenth century. Gazetteers of production sites have identified ten 'principal' production sites and forty-five other sites in the Peaks. Just outside the current survey area, on the moors between Huddersfield and Oldham, millstones were sourced from Millstone Hill above Meltham (SE082090) and Millstone Edge above Saddleworth (SE013103).

The label 'North West England' usually refers to the historical counties of Cheshire, Lancashire, Westmorland and Cumberland, but the Pennine chain west of the main watershed is topographically and climatically more akin to the North West even though it is more often lumped with 'Yorkshire and the North East'. For the purposes of this survey, the western side of the Pennines is included, whereas Cheshire and southern Lancashire are not. The present survey incorporates the western side of the main Pennine chain along with its offshoots the West Pennine Moors and the Forest of Bowland. Much of Cumbria has no geological conditions that could have generated millstone production, though sandstone bedrock to the west of the River Eden, around Penrith, and along the west coast north of Whitehaven was worked on a relatively minor scale.

Of the fifty-six production sites identified by this writer, from a historical or archaeological perspective, nineteen are in the Central Pennines (effectively the Yorkshire Dales), ten in the South Pennines (mainly between Leeds, Bradford and Skipton), nine in the North Pennines (mainly in Cumbria), and six in the Forest of Bowland. The remainder are spread across the rest of Cumbria

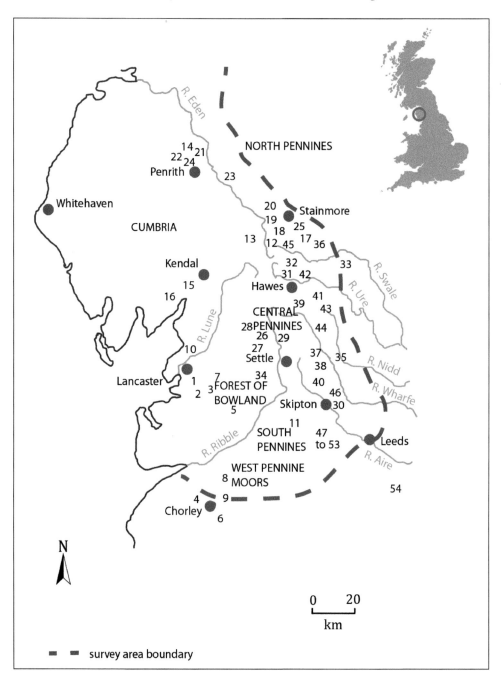

Location map of the survey area.

(eight), the West Pennines between Blackburn and Chorley (two), with two outliers to the west of the upland massifs.

Elsewhere, millstone making is known from at least fifteen sites in the Forest of Dean and the Wye Valley from the Roman era, with grindstones being made

from the mid-thirteenth century and exports of millstones to Somerset in the sixteenth. The industry in Scotland has been well documented from at least 1584; while in Ireland fifty-seven millstone quarries have been identified across the whole island.

Of relevance to the north-west of England and the Pennines west of the main watershed, two sources illustrate the level of previous research into the industry here: one gazetteer of production sites from 1992 listed no sites at all; while a comprehensive bibliography from 2007, which includes twenty-six literature sources for England, three for Scotland, five for Wales and one for Ireland, has just three for Lancashire and none elsewhere in the survey area. It is an under-researched industry outside the Peak District.

Historical Evidence

Within this research area relatively few of the production sites were worked on a large-scale commercial basis, and even for these the body of surviving archival material is limited. Where the level of ground evidence suggests extensive workings, there is often a lack of written records. In both cases, to find relevant documentation can be accidental and unexpected. Furthermore, many of the sites were abandoned before *c.* 1800 so the probability of there ever having been systematic written records is slight. Nevertheless, for some sites there is sufficient survival to enable a meaningful picture to be constructed.

The Cistercian abbey of Holm Cultram in north-west Cumbria was granted the right to take millstones from lands owned by Alan, son of Ketill in Hensingham, now on the outskirts of Whitehaven, by a deed registered 1200–10. The abbey was also granted liberty to graze their oxen at Hensingham while digging and carting the millstones, which gives us a rare indication of how they were transported. Later that century, elsewhere, two millstones were purchased, one destined for a corn mill at Castleford and one at Knottingley, both south-east of Leeds, at a total cost of 7*s*, which presumably included carriage from the unstated production site – both were royal possessions. This record is one of the earliest confirmed costings of millstones in England.

In 1257 Geoffrey Pigot granted to his lord, Ralph de Neville, the right to take millstones from his quarry in Melmerby (Coverdale) for use in Ralph's mills in Richmondshire. The quarry in question – called de Gryff – has been tentatively identified as Griff Head Quarry, and each pair of millstones cost 4*d*. The agreement asserted: 'It is long since millstones have been obtained from Melmerby.' This rather vague sentence can be interpreted in two ways: either that no millstones had been worked there for many years, or they had been sourced over a lengthy period of years. About the same time, in 1269, Adam of Capernwray, north-east of Lancaster, granted to the Cistercian Furness Abbey, of which he was a major benefactor, liberty to take millstones from his lands

Griff Head Quarry, Melmerby. Almost certainly the source of millstones owed to Ralph de Middleham by Geoffrey Pigott in 1257.

in nearby Kellet. This right was later extended by Gilbert de Kellet. Around the northern fringes of Bradford and Leeds there were several known early production sites, such as Cragg Wood, Calverley Wood, Buck Wood, Midgeley Wood, Baildon Bank, Black Hills (Cottingley) and Idle.

In 1321/2 a pair of millstones was despatched from Idle to Fleet Mill, a water-powered corn mill close to the royal castle at Rothwell, south-east of Leeds (NGR SE342283).

From the Elizabethan period there is a useful entry in the Hornby Castle estate muniments for 1581. Thomas Marshe, who operated the manorial corn

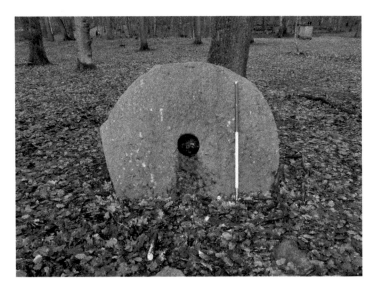

A 1.68-metre-diameter domed roughout propped up with the central eye cut half way through, lying in Cottingley Park woods. It has no obvious flaws, so why it was abandoned remains a mystery.

A quarry on Baildon Bank from where millstones were produced.

mill at Hornby, inland from Lancaster, rode to Ingleton Fell (Ingleborough) with two assistants to purchase and carry away 'one pair of mylnestones' for his mill. His total outlay was £8 6s 4d, which included 26s 8d for the millstones, 13s 4d for carriage to the mill and 15d for their expenses. Several abandoned millstone *roughouts* lie at the foot of the main summit massif, including one of the probable size required by Marshe.

Early evidence of millstone working on Penrith Fell is found in a lease to Cuthbert Orpheus of Arkelby Hall (NY14253970) in 1626, by which he was granted rights to work 'the quarry of millstones' on the Fell at 40s annual rent. The precise quarry cannot now be identified, but may well be one on Beacon Fell just north of Penrith. Orpheus did not operate the quarry himself but employed others to do so.

A series of similar late seventeenth-century indentures, this time concerning the recently rebuilt Old Mill in West Burton (Wensleydale, SE01858673) granted a succession of millers liberty to get millstones within the manor of 'Thoralbie Burton Walden'. Field walking on moors within the manor has located abundant evidence of stone working on Wasset Fell and Mile Stone (Millstone) Hill, but not of millstones. From this it can be assumed that millstones were worked as and when needed rather than on a commercial basis. The same scale

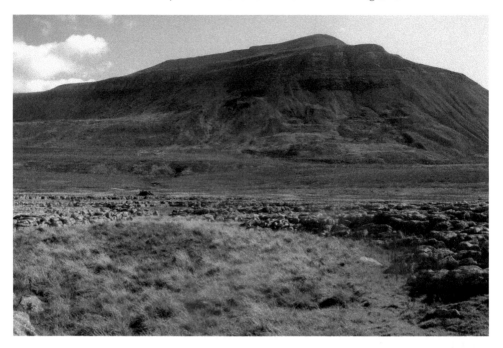

Horizontal Millstone Grit forms the uppermost layer of Ingleborough's summit plateau. Several roughouts lie abandoned where they came to rest below the steep slopes of Falls Foot and Black Shiver.

of working is also apparent on Penhill, an extensive upland massif east of West Burton (Wensleydale). Penhill Park and Penhill Crags are littered with disused stone workings seen as quarry pits, waste heaps, discarded worked stone and early tooling marks; the former area focussed on flagstone production but millstones were sourced from the Crags. As with West Burton, this was not a commercial operation but worked on an intermittent basis. Around 1700 the l'ansons were millwrights at West Witton Corn Mill (SE059883) and Carperby Mill and, as and when required, they obtained consent to 'get a sound and good Milstone' within Thomas Sudell's estate on Penhill.

Orpheus, Norton and Sudell were minor members of the landed gentry far down the social scale from the redoubtable Lady Anne Clifford who owned vast estates in Westmorland as well as the castles of Brougham, Brough, Appleby, Pendragon and Skipton. Various water-powered corn mills lay within her estates and entries in estate accounts for the 1660s refer to purchases of millstones from within the valley of Mallerstang.

Returning to Kellet, an antiquarian account of Warton Parish, near Carnforth, compiled 1710–40, drew attention to a quarry where 'they hew out entire Miln-Stones equal in Goodness to those got upon Rumblesmoor in Yorkshire, or to those of Derbyshire'. The antiquarian John Lucas observed that Kellet millstones not only met the needs of local corn mills and in coastal settlements but were also exported to Ireland, the Isle of Man and elsewhere.

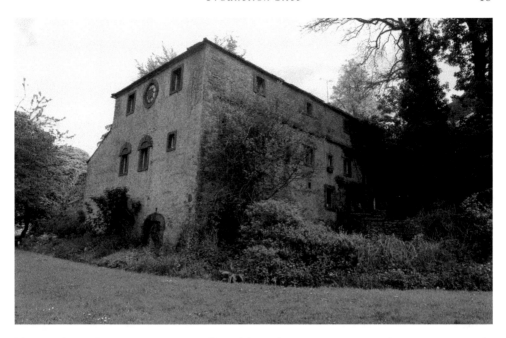

The long-disused Bongate corn mill on the River Eden in Appleby-in-Westmorland, owned in the 1660s by Lady Anne Clifford.

The remains of a series of shallow delfs at Dole House in Pendle, where millstones were mentioned in 1740.

Contemporary with workings at Kellet, millstones were produced in the Pendle Hill area of north-east Lancashire, probably on a small scale judging by ground evidence centred on SD83563935. By a legal agreement drawn up for John Towne, a yeoman farmer of Wheatley Lane in Pendle in 1740, he promised to leave all 'stone troughs, millstones and other loose stones' at Dole House in Roughlee Booth when he gave up his tenancy.

Moulds Top above Arkengarthdale highlighting the proliferation of gritstone outcrops on the moor.

Archaeological Evidence

Of the fifty-four production sites visited in this survey, forty-four have clear evidence on the ground of millstone working; twenty-two of them have archaeological evidence but no located documentary evidence. Ground evidence takes two forms: millstone roughouts, i.e. what was obviously intended to become a millstone (thirty-four sites); and parent rock displaying tooling marks consistent with a millstone having been worked and removed or marked out ready to be shaped (ten sites). The majority of millstones recorded were roughouts in various stages of production though on some sites there are abandoned completed roughouts. The number of roughouts per site varies enormously, each total equating to the scale of production whether viewed as mass production over a short timespan (decades perhaps) or over an extended period of time (centuries). Of the thirty-four production sites with visible roughouts, 66 per cent have less than six and 19 per cent have ten or more. Two sites have twenty-nine visible roughouts – Wild Boar Fell and below Hangingstone Edge in Westmorland – while Millstone Lumps on the northern edge of Addingham Moor above Lower Wharfedale has twenty-four. Black Coppice on the western fringe of the West Pennine Moors has eighteen,

Woodhall Greets above Askrigg in Wensleydale has seventeen, and Moulds Top above Arkengarthdale has fourteen. From archaeological evidence alone, these five localities can be seen as long-lived and large-scale, whereas those with less than six must be seen as intermittently worked. Several sites have minimal evidence on the ground but strong archival representation: Braisty Woods (Nidderdale) and Whittle-le-Woods are two such sites.

To the south-east of Preston, gritstone was worked in a series of quarries between Whittle-le-Woods and Hoghton and these are the only major production sites in the entire survey area below the 200-m contour. Production at Whittle was sufficiently important to warrant the cutting of the southern arm of the Lancaster Canal to connect the quarries to the Leeds & Liverpool Canal, and a basin was created in the heart of the village, in 1816, with millstones despatched as far as Halifax, Bradford, Leeds, Kendal and Coniston (Cumbria) through the nineteenth century. A trade directory for 1825 noted 'four valuable millstone quarries' at Whittle, though the industry had a much older genesis, as evidenced by the comment by poet and antiquary John Leland in 1536 that at Whittle he had seen a 'great quarry out of which men dig very great and good millstones'. A further archival source recorded that lord of the manor James Anderton of (nearby) Clayton gave the manor to a third party in 1666 but reserved to himself the right to take millstones for Clayton (corn) Mill out of the quarries, 'roaches' or 'delfs' at Whittle at the rate of 13s 4d per millstone.

The preserved canal basin at Whittle-le-Woods, from which high-quality millstones were exported in huge numbers from 1816.

3

Creating Millstones

Millstone roughouts were produced in a variety of situations and, on larger sites, over time production became more industrial in scale leaving a more significant impression on the landscape. In some instances surface outcrops – even just huge boulders lying on the surface – were worked and several of the larger sites were spread among boulder fields below prominent crags. In Mallerstang (Cumbria), for example, extensive boulder fields below Hangingstone Scar and High Loven Scar contained long-lasting and major production sites on Elmgill Crag (which is not a crag at all, but a cascading

Wild Boar Fell looking towards the extensive boulder fields below The Band, High White Scar, Yoadcomb Scar and, far right, the most prolific production site on Yoadcomb Hill.

series of massive land-slip boulders) and Swineset, while on the opposite side of the valley on the Wild Boar Fell massif, below Yoadcomb Scar, High White Scar, and The Band, as well as above Sand Tarn, there is equally impressive ground evidence of working on a major scale.

Where gritstone outcropped at the surface, such as in the Bowland fells in north Lancashire or on Abbotside Common above Wensleydale, roughouts were either hewn from the outcrops or dug from shallow delfs.

Elsewhere, and later in the chronological cycle of production sites, Millstone Grit strata were quarried back into the hillside as a series of quarries with vertical rear faces and level bottoms. The later phase of exploiting the northern edge of Addingham Moor (Lower Wharfedale) or Baines Crag (north Lancashire) is apparent today as impressive quarry faces.

Archaeology cannot really reveal any detail about how production was organised and managed, though it is probable that on smaller intermittently worked sites, as on Penhill, small groups or pairs of men just got on with it, whereas on more commercially oriented sites there was a hierarchy headed by a master mason. Archaeology, however, does confirm that millstones were despatched as roughouts, i.e. in an unfinished state: final *patterning* of the grinding surfaces was undertaken by a *stone dresser* at the corn mill. On the production sites the men who made the initial shape of a roughout, who defined its perimeter in a block of loose rock – called by them a *tumbler* – or on the face of an outcrop or earthfast boulder were variously called *stone getters*

The prominent gritstone outcrop at Millers House on Brennand Great Hill was extensively worked for millstones. Nine roughouts lie among the rocks along with other evidence of tooling.

Millstone Lumps lies below the dramatic northern edge of Addingham High Moor. This was a major millstone production site for at least 200 years.

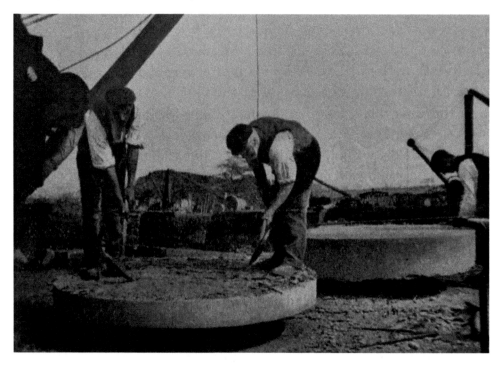

Two millpickers at work on a thin millstone in an unknown Yorkshire quarry in 1905. Behind them a mason puts the finishing touches to a thick grindstone. To their left is the Scotch derrick used to lift and move the stones, while in the distance a stack of completed stones is seen.

or *masons* or *hewers*. Those who took the roughly shaped rock a stage further, by tooling its edges and faces, were called masons or *millpickers*, which can be defined as one who creates the grinding surface of a millstone roughout.

There is archaeological evidence that the millpicker may have been preceded by a more skilled mason, or perhaps that apprentices were set to work on rough dressing. This evidence comes in the form of broad grooves cut into the face of some roughouts in the form of a cross: the grooves were most likely cut by a skilled mason to show the less-skilled worker the final depth to work to. This feature has been noted by others in Hathersage, Northumberland, Gwent and Anglesey, and in Nidderdale within the survey area. One small, cross-carved roughout lies on Embsay Moor. Another possible indication of on-the-job training takes the form of a very small block on Wild Boar Fell, set among a major millstone production site, where a circular line of holes has been picked out with another hole set dead-centre: this can perhaps be seen as a training exercise for an apprentice in how to chisel a perfect circle and get the central hole in the right place.

Across the survey area close examination of roughouts and tooling marks reveals that methods varied from site to site. In some instances the first stage was to scribe the intended circumference with a series of holes or wedge pits gouged out with a pick or *mash hammer*, or to use a *scutching hammer* to etch a continuous groove or, as seen on one tumbler block below Hangingstone Scar, using these tools to define the circumference in the form of a scalloped-edge pastry cutter. Once the circumference was defined, the waste rock was prized off the intended roughout using iron wedges hammered in rotation and a *gavelock* (crowbar). The waste bits – *negatives* – can often be recognised even if there is no other sign of a roughout nearby.

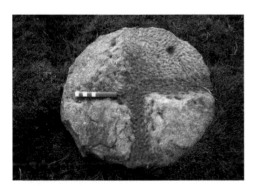

Above left: A small early-stage roughout lying among a medieval hills and hollows landscape on Embsay Moor north-east of Skipton. Tooling on this one marked out a cross-shaped 'groove' that may have been designed by the master mason to show a less-skilled hewer the desired depth.

Above right: A probable example of practice tooling on a tumbler block among the boulders on Elmgill Scar. Was this a circle chiselled out by a trainee learning how to cut the eye of an intended roughout?

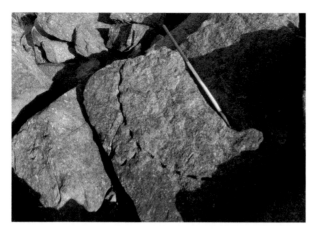

Above left: This block was in the very early stages of being worked, also on Elmgill Scar. The curving line of wedge pits was intended to mark out the roughout's circumference, and the two wedge pits at an angle to the curve were to split the negative into two pieces. Unfortunately, the top part of the block seems to have broken off, leading to abandonment of this roughout.

Above right: On Yoadcomb Hill this roughout has been fully detached from its parent block by chiselling away between the wedge pits to create a 'pastry cutter' effect on the rock. The whole of the circumference is fully tooled.

Seen in a deep hollow among the chaos of boulders is this negative. The millstone has been removed from the hollow, leaving the debris created by splitting it from its parent block. The same 'pastry cutter' effect is visible on the curving edge of the negative.

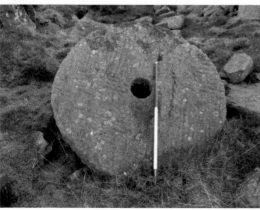

Cross-peck dressing seen on the face of a near-complete roughout at Millers House, Bowland. The hewers must have been maddened when the upper part of the stone failed.

In some cases the whole roughout was shaped, the edges were chiselled using a *broachaxe,* and the upper surface was taken to its final on-hill state using a *kevel* (axe-hammer) and *boaster* (broad chisel) or *scappling* axe/hammer prior to removing it from its parent block. The end result was a stippled effect across the face of the roughout. Close examination of the face of many roughouts suggests from the spoke-like orientation of tooling marks that the millpicker stood on top of the roughout working from the centre towards him as he painstakingly moved round it. Many roughouts show that the parent rock was reduced in size with negatives progressively detached so that the roughout could be shaped lying on the ground, or propped at an angle: for centuries this was achieved by gouging a line of wedge pits (averaging 100 mm in length) with a broachaxe and a maul, followed by levering it apart with a gavelock or *bottoming pick*. After *c.*1800, though, the *plug and feather* system was used. Circular holes were hand-bored to a vertical depth and horizontal spacing of *c.* 300 mm; a pair of cast-iron feathers was slotted into each hole and an iron plug pushed between them. Hitting a maul on each plug in turn, the rock came neatly apart leaving a row of half-cylindrical grooves in the rockface.

It cannot be claimed that a roughout's central hole – the *eye* – was the final stage in the process because there is conflicting evidence across the survey area. In some cases roughouts appear ready to be sent off the hill with no eye while in others the eye was cut to half depth as one surface of the roughout was tooled to be cut from the opposite side when the roughout was upturned. One

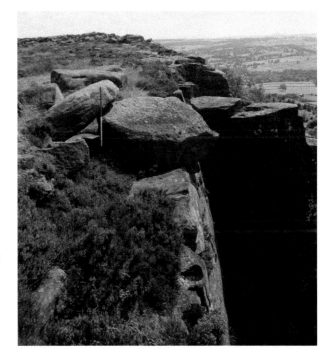

This scene is at the top of Baslow Edge in the Peak District (SK2601571262) and is a good illustration of the lengths to which masons went to source the best potential millstones. Here a near complete, slightly domed roughout was propped against another rock so that the men could finish off the upper face while the lower (hidden) face seems from close examination to have been completed. The vertical drop would make most people think twice about working here, especially given that the horizontal block against which the other is leaning also seems to have been in the masons' sights.

Here, below the summit plateau of Wild Boar Fell, work had commenced to split off the upper section of rock from the rest by scribing a horizontal line of wedge pits across its face. All four faces needed this treatment, making it a laborious and time-consuming task.

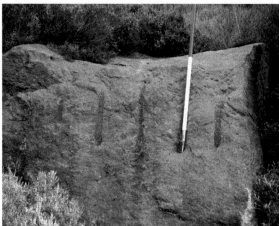

From about 1800 a new method of tooling was introduced, much more efficient and quicker than gouging wedge pits. Lines of tubular holes, about 300 mm deep and 300 mm apart, were drilled using the plug and feather method. Once all had been drilled to the desired depth, a bar was pushed into the resultant crack to prize the rock apart. This writer has seen one operative splitting a block as big as this using the traditional method ... in less than five minutes.

Seen high up in Mallerstang, below the uppermost gritstone scar, this block is a puzzle. It is clearly a very large tumbler and the hole has not been naturally weathered as there is evidence of tooling as though this was going to be the eye. It is difficult to understand why the hewers started in this way rather than scribing out the intended circumference of the roughout.

extraordinary example can be seen below High Loven Scar: a large squared tumbler lying at an angle has what seems like an eye cut into the centre of it. No other tooling marks exist so it may have been another example of a training exercise for an apprentice.

4

Infrastructure and Transportation

The masons, hewers and stone getters who spent hours each day toiling at the various production stages with iron tools in remote locations at high altitude, often away from an obvious source of water, faced real problems. It did not take long for an iron pick or chisel to become blunt and, to maintain efficiency of output, they needed regular sharpening, and it might be assumed that larger production sites had smithies to keep the men supplied with workable tools; however, the archaeological evidence within the survey area does not support

Smithies are rarely seen. This one lies among early stone working sites on Embsay Moor. Beneath the 200-mm scale bar is the hearth lintel behind which the flue passage runs out of the structure, which measures 3 m x 3.2 m internally. Just out of shot is a stone plinth, probably an anvil base. The whole structure was very crudely built but would have served its purpose.

this notion. Embsay Moor does have two obvious ruinous smithies complete with hearth and forge, a flue and a stone-block anvil contained within small stone buildings. Also, nestling below the crags of Millstone Lumps below Addingham Moor is a very crude structure that may well have been a smithy. Beyond these, though, the evidence is lacking.

Working at high altitude, in all weathers, the workers were exposed to often challenging working conditions. It is not surprising therefore that the larger production sites have small crude shelters, generally facing away from

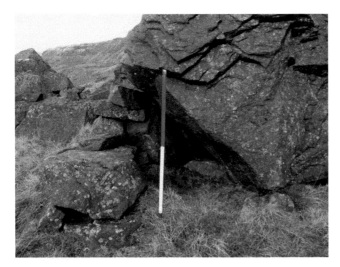

Left: A crude shelter made by piling up boulders against a large tumbler block to give minimal protection against the weather. This one is within Elmgill Crag.

Below: This ruinous two-person shelter below the summit plateau of Ingleborough originally had a corbelled roof. Facing north, it gave protection from the prevailing winds.

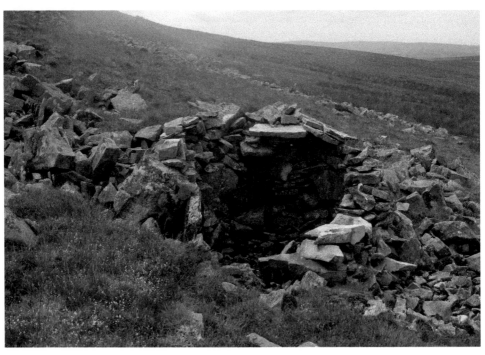

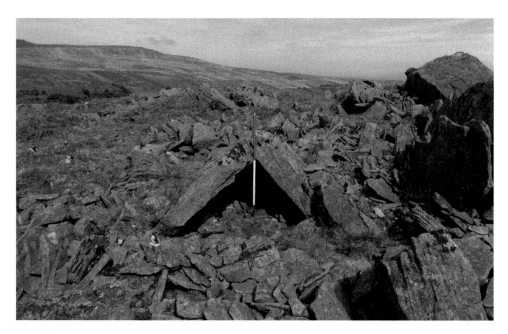

At the foot of Elmgill Scar is this one-person shelter formed of four large slabs of rock set in the form of a ridge tent. Internally it is 2 m long by 1 m wide at the base and 600 mm high at the ridge line. Facing south, it would have kept the rain and cold off but the occupant would have been very uncomfortable.

the prevailing wind. Many have corbelled roofs set on crude drystone walls, with the entrance left open; others were formed by enhancing natural blocks; some consisted of a short curved wall behind which the workers gained some shelter, and among the chaos of boulders that is Elmgill Crag there is one stone structure cleverly built like a ridge tent.

Perhaps the most puzzling aspect of millstone production is how the roughouts were transported off the fells. In a quarry situation, as at Whittle-le-Woods or Braisty Woods, a tripod sheerlegs or a Lewis crane or Scotch derrick was used to lift the stones onto a wagon that then trundled away from the quarry face along trackways, or *postgates* as they were called in the Pennines. Derricks, though, needed a firm base. What in some cases defies explanation is how roughouts were moved from within boulder or tumbler spreads, as at Elmgill Crag or Millstone Lumps; or from high up in the fells, as below Hangingstone Scar or the summit plateau of Pen-y-ghent; or from high up on Ingleborough or Wild Boar Fell, well beyond the reach of wagons; or, indeed from millstone outcrops in the midst of endless peat haggs and groughs, as in Bowland or on Abbotside Common. In such situations, and especially in wet conditions, any form or wheeled vehicle of even a sledge would have been out of the question.

As an exercise in trying to make sense of the scale of this problem, the author calculated the weight of one completed roughout lying on High Millstones on

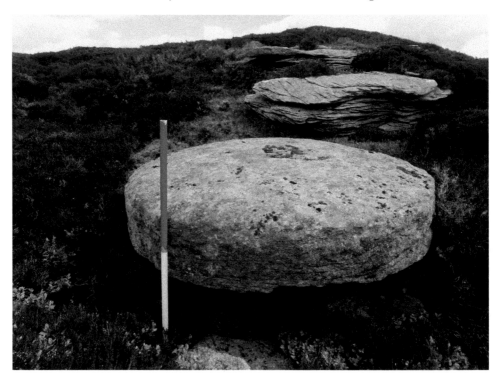

High and Low Millstones are two long ridges on Abbotside Common, above Wensleydale, where several millstones lie abandoned including this one that was ready for despatch. It is 1.7 m in diameter and 270 mm thick at the edge; its weight is computed at 610 kg, and it seems to have no imperfections that would have caused it to be discarded.

The landscape between the Abbotside site and the nearest firm ground is dominated by deep deposits of peat with upland bog interspersed with deep channels that would have proved an extreme logistical challenge to getting roughouts off the moor. We do not know how they did it.

Abbotside Common, over 1 km (in a straight line) from the nearest trackway across deep peat groughs. It is 1.7 m in diameter and 270 mm thick at the edge; it weighs over 600 kg. There is no way a wagon or a sled could have made the crossing and as the ground is broadly level (apart from the groughs) it could not have been rolled. It simply defies explanation.

Daniel Defoe observed a method used near Chatsworth in Derbyshire: to transport millstones from a 'very high mountain' the workers 'roll[ed] down a pair of those stones coupled with a wooden axis'. Roughouts from the moors east of Saddleworth were also rolled downhill in the eighteenth century. A reference from 1677 described how small roughouts (below 760 mm in diameter) were carried slung between two ponies: this could have worked on Abbotside Common, but not with a stone weighing over half a ton. Rolling was certainly one answer to the question, and there is archaeological evidence of this on some production sites. Below the main working grounds on Ingleborough, Gragareth and the southern part of Wild Boar Fell millstone roughouts lie abandoned at the hillfoot. Some are fractured or split in two. It has to be the case that these were all rolled down freely and left to gain momentum with the hope that they would come to rest intact and accessible. The sense of frustration that must have been felt when things did not go to plan would have been enormous, as would the colour of the language.

Wooden sleds were used on some sites to drag millstones across moorland: a definition of a *sleide* from 1552 described it as a 'sledge or truck with low iron wheels' so this was not the typical sled set on fixed runners. In Ireland flat-bed

We do know, however, how they managed it on Ingleborough. Millstone Grit was sourced high up on the hill and it is clear that the roughouts were set upright and allowed to roll down under gravity in the (sometimes forlorn) hope they would not break or end up beyond recovery.

This roughout, with one segment missing, did not behave as intended but came to rest in a boulder field below Falls Foot on Ingleborough, where contact with other blocks ended in disaster.

slypes (sleds) were used with a pulling horse at the front and a break horse at the rear for descents. In Northumberland sleds – here called *hoys* – were used where wagons could not go. Sleds most likely were used on Embsay Moor where deeply grooved and carefully engineered sledways lead from production sites off the moor, and sledways can be identified on the ground leading away from Millstone Lumps.

A clue associated with late phase working can be seen on Millstone Lumps: below a high-level quarry on a steep slope in a non-natural gully, there is a large squared block of gritstone 1.7 m long by 500 mm wide; it has a 250 mm-square hole cut to a depth of 500 mm. Almost certainly it was the base for a stanchion supporting part of a chain or cable for lowering millstones to a sledway.

Leading southwards off Embsay Moor is a series of sunken ways, as seen in this photograph. They were sledways for dragging millstones and other stone products off the moor, presumably behind a team of oxen and/or draught horses.

The same method was also used to transport roughouts from Millstone Lumps below Addingham Moor and this long-range view shows four sledway grooves heading north downhill. When rain and mud made one groove impassable, hauliers transferred to another groove.

Archival sources provide some insight into the problems of transporting millstones. For instance, a verdict of Ireby Manor Court in Cumberland, in 1653, concerned a claim for reparations caused by loading and moving millstones. In summer 1665 Lady Anne Clifford's estate in Westmorland paid Lancelot Machill of Crackenthorpe for 'leading ye said Millstones from Loven Scarre to ye said Bongate Milles' at Appleby; Loven Scar forms part of the Hangingstone Scar series of production sites. The journey was 20 km with the first 1,500–2,000 m of crossing often wet moorland in a descent of 340 m, giving an average gradient of 1:4 or 1:6. To achieve the impossible, Machell used thirty-two oxen, six horses and twelve men and it took four days to get the pair of roughouts from Loven Scar to the mill. Machill was paid £9 in total, plus an extra 11s paid to 'severall of ye Inhabitants of Mallerstang for going through their grounds' – one can imagine the mess caused by the oxen and horses. What is frustrating is that the account does not state what kind of vehicle was used; it can only have been a sled. On the same day Johnathan Gleddall was paid £4 for the 'getting of two Millstones on Loven Scarre' so the cost of transportation was more than double the cost of the stones.

In 1683 the accounts of another estate record the payment of £9 19s to Jo Ostley 'Millstone-getter at Kellet' for supplying two millstones delivered to

Left: Higher up the fellside, this gully was cut below a quarry cut back into the gritstone strata so that roughouts could be lowered by means of a rope or chain.

Below: The only surviving evidence of this is a large block set partway down the gully. It is 1.7 m long by 500 mm wide and has a central hole 250 mm square and 500 mm deep. This is interpreted as the base for a stanchion supporting an overhead cable or ropeway.

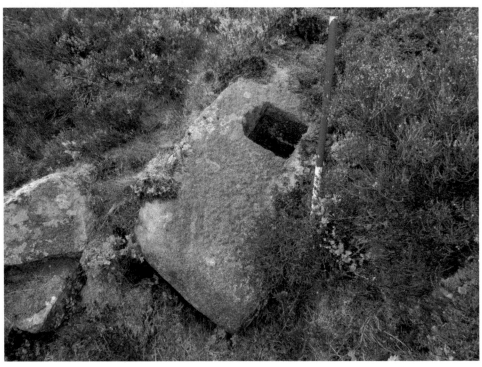

Lady Anne Clifford authorised the purchase of a millstone from Loven Scar in Mallerstang in 1653 and a large team of oxen and horses was engaged to drag it down to the valley road. As can be seen in this photograph, the terrain is extremely difficult and it is no wonder it proved such an epic journey.

Windermere Waterfoot in the Lake District. From Kellet to the south end of Windermere is *c.* 36 km. A further 5*s* was paid to Richard Robinson as wayleave for crossing his land at Waterfoot and 16*s* to Thomas Brathwaite for 'Boating of them up Windermere-water'. The stones were landed at Rothay Bridge, Ambleside. A further 1*s* was disbursed for ale for the men on this mammoth journey. Beyond Rothay they faced a separate 3 km overland journey for each millstone. The first stone was taken on a *dragg* (a long open vehicle) through Rydal Low Park following a trackway along the River Rothay, but this proved very difficult so the second stone was carried on a *trail* (a wheeled cart rather like a gun carriage) along what is now the A591. The Rydal estate paid for all costs for its mill at Rydal, totalling £11 1*s*.

This record also illustrates how long a pair of millstones lasted: in 1659 the corn mill at Rydal was extensively repaired and a pair of new millstones was purchased, also from Kellet at a cost of 10 guineas – so slightly more expensive than in 1683. This pair was dragged to Waterfoot by oxen. Expenses included 2*s* 4*d* for unloading them at Waterfoot, 1*s* for making the drags to haul the stone on, 13*s* 4*d* for food and drink for the hauliers, and 2*d* for the person who delivered the message that they had arrived at Waterfoot. The total cost was £14 6*s* 10*d*.

In 1702 the Worton estate in Wensleydale needed to renovate its manorial corn mills at Askrigg and Bainbridge. A pair of millstones was ordered for Bainbridge from Woodhall Greets and three men were paid 15*s* 6*d* for leading a 'great Milnstone and a runner ... October first' using six oxen and two horses; 12*s* for making a new iron bolt for the 'Milnstone Sleid weighing 40 pound'; 5*d* each for a day on the 'Millstone Moor'; 4*d* each for a day making ready the sled and wheels; 4*d* for mending the sled's cog wheel; and 5*d* each for a day leading the millstone from source to mill. This journey was 6 km; the number of days was not given.

Addingham Moor, Wharfedale

Rombalds Moor (the Rumblesmoor of the 1740 Kellet anecdote) divides Wharfedale from Airedale and the north-western section is Addingham High Moor. Along its northern edge is a very steep 3-km-long escarpment. Millstones were worked on a relatively small scale at the east end, in Heber's Ghyll on the edge of Ilkley, but on a large scale at the opposite end at Millstone Lumps (between 325 m and 380 m AOD). Here the escarpment was cut into not just for millstones but also for dimension stone for gateposts, sills and lintels. Below the crags along the edge of the moor a chaotic mass of gritstone boulders – tumblers – was worked for millstones and, below this, isolated outcrops or fallen blocks were worked. Twenty-four roughouts were logged by this writer, though this is most likely not the full total, along with other tooling evidence. The two in Heber's Ghyll were both well advanced, one having the eye cut right through and the other part cut.

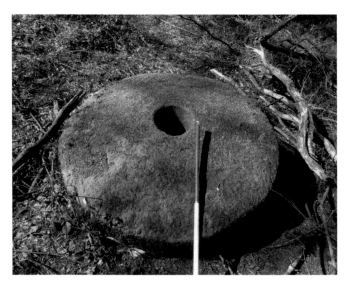

Heber's Ghyll forms part of the northern slopes of Rombalds Moor at Ilkley. It is steep sided, well wooded and broken by outcrops of Millstone Grit. Two roughouts lie within the woods pointing to this having been a production site. This one, propped up against bedrock, is 1.54 m in diameter and is domed, being 280 mm thick around the edge but 410 mm at the centre. It looks to be in perfect condition and is complete, so is yet another mystifying example of a good abandoned roughout.

Millstone working here extended over a long period of time, with the earliest documentary evidence being a rental from 1650 or 1654; however, it may well have begun many years before that. The freeholders of Addingham township had the inalienable right to work stone here on short-term leases and to sublet the right to work; for instance, from 1683 to at least 1723, John Wainman of Addingham, mason, was granted 'ALL that Cragg Rock and Quarry of Stone commonly called Windgate Nick ... and full and Free Liberty to dig for Breake Cutt Hew Stones therein for Millstones' for a term of eleven years at £6 annual rent payable to the Overseers of the Poor. Wainman was required by the term of his agreement to pay 6s 8d per pair of millstones beyond the first eighteen pairs in any one year. At the minimum, Wainman alone produced forty pairs of millstones between 1683 and

Above and right: These two images also show a completed roughout in sound condition, here in the boulder field below Millstone Lumps. Above the boulder field there is a substantial quarry from which this stone must have been sourced, but there is no ground evidence now of how they managed to get it this far or why they took it no further.

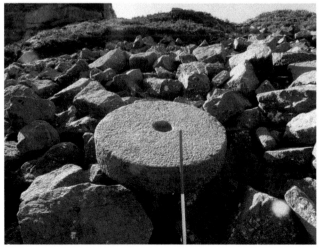

1723, a figure which emphasises the scale of production here. In 1789 thirty completed millstones lay within the quarry; in January 1798 two 'grey stones' were purchased from here for Bainbridge Mill in far-away Wensleydale.

Of the two dozen or so roughouts logged during the field survey, for which firm measurements could be taken, twelve were in an advanced state of working or seemingly ready to send off the moor while the rest had not been worked beyond the early stages of tooling. Ten had a central eye fully or part- cut; four lay in shallow delfs whereas the others were cut from large tumbler blocks. In addition, evidence in the form of tooling marks was seen on four blocks.

Early workings focussed on tumbler blocks and gritstone outcrops below the crags and further downhill, while later on attention turned to the crags themselves. A number of discrete quarries were cut back into the rockface where production was on an altogether greater scale. Working here came to an end by 1800.

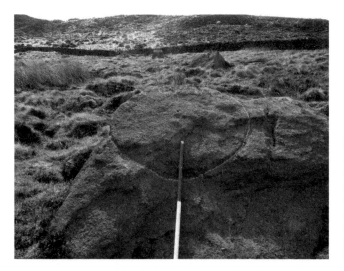

Much lower downslope at Millstone Lumps and from a much earlier period than the one left in the boulder field, this earthfast rock was selected for a roughout. Work only proceeded as far as lightly chiselling out the intended circumference, here highlighted with chalk.

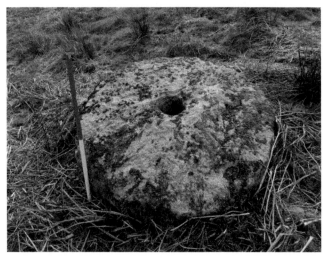

Also hacked out of a small outcrop at an early period is this completed roughout. It measures 1.6 m by 300–370 mm so is another early example of a domed roughout.

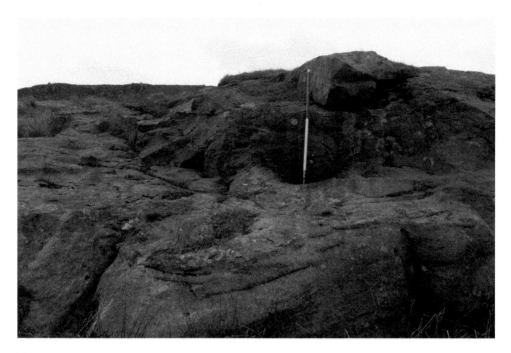

The impression of this domed millstone is clearly seen in the parent rock from which it was hewn as a vertical circular face. Separating a roughout vertically may have proved more taxing than doing it in the horizontal plane.

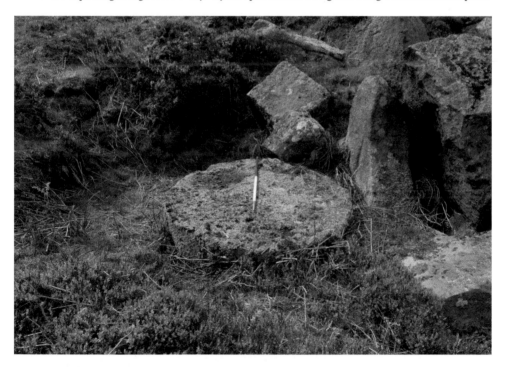

Millstones below Millstone Lumps were also sourced at an early date from shallow delfs like this one, which still houses a part-worked roughout that was finished on its upper face and circumference but not on the hidden face. This one is 1.65 m by 230 mm.

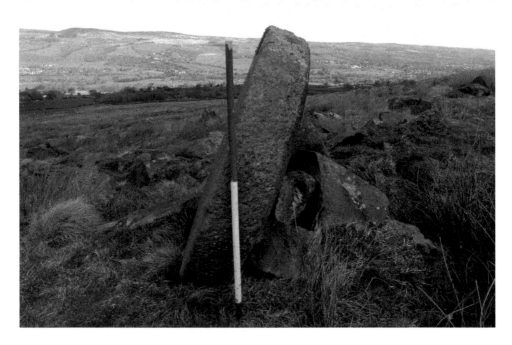

Above: Across the slopes below Millstone Lumps there are several roughouts like this one. It was fully completed, including the eye, and had been set vertically resting against rocks ready to be collected and taken away, an event that never happened.

Left: Among the later areas of working among the Lumps is this large quarry hole; set within it is a stone that speaks volumes about how the masons went about their work here. They selected this large squared block and shaped the roughout to perfection around its circumference and on the upper face, but it is still firmly attached to the parent block. As we have seen in Mallerstang and elsewhere, the roughout tended to be separated first. This goes to prove that working methods and strategies varied from place to place.

6

Black Coppice, Anglezarke

About 8 km south of Whittle-le-Woods, east of Chorley (Lancashire), the escarpment of the West Pennine Moors rises abruptly to Anglezarke Moor at 220 m AOD. Along the top of the escarpment, bounded on the north by Dean Black Brook, lies a large area called Black Coppice. The escarpment was cut into by quarrying for Millstone Grit for various end uses but on the open moor millstones were worked on a large scale: eighteen roughouts have been

On Black Coppice in the West Pennines many millstones were hewn from shallow delfs cut down into surface bedrock. This delf has several roughouts at varying stages of shaping.

identified by the author in various stages of production. Some were hewn out of gritstone outcrops lying on the surface, but others were sourced from shallow delfs dug down below the surface: one, at SD6204018657, has multiple part-worked roughouts. A survey undertaken in 1322 valued millstones in the 'wood of Horwich' at 60*s*; Black Coppice lay within that area, but a manorial account from 1523/4 noted that the 'delph of millstones' yielded no profit. When working here ended is not known.

Of the roughouts seen, only three were worked to completion with ten being in the early stages; five roughouts were logged within shallow delfs on the moor top. None was cracked or broken, and only one had the eye cut through.

This early-stage roughout lies in another delf; the scene gives an impression of the terrain on the moor.

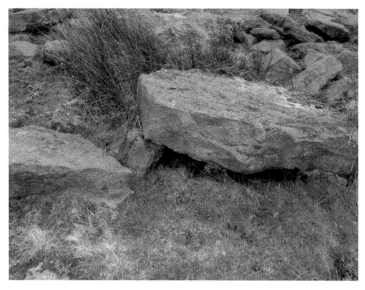

This one, however, also at an early stage, sits on the moor top and was being hewn from outcrops rising above the ground surface.

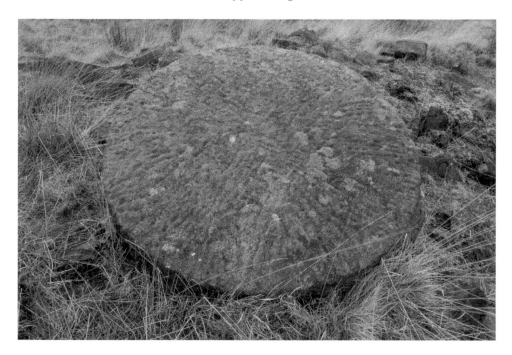

Black Coppice displays all stages in the life of a roughout and this particularly good example has very clear peck-dressed tooling marks on its upper face. Any further work on this was the preserve of the mill operator back at whichever mill had intended to purchase it.

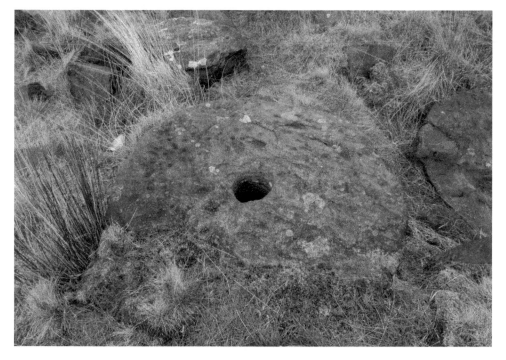

Here, again on the surface, two roughouts lie next to each other slowly being covered by vegetation growth. Who knows how many other millstones lie buried like this?

Here lies a source of frustration for the masons. It seems to have been more or less completed, and even had the eye fully cut, but for whatever reason a flaw the workers had not noticed caused it to split in two.

Given how steep and high the escarpment is, transporting the roughouts off the moor must have been a real challenge. It is difficult to imagine any kind of wheeled vehicle being used and the rocky nature of the descent from the moor would have ruled out rolling them down.

Braisty Woods, Nidderdale

Between the River Nidd at Summerbridge and Brimham Rocks above Nidderdale to the east of the Yorkshire Dales the landscape is well wooded, but not as much as in the medieval era. In the centre of the woods sits a disused quarry that worked Millstone Grit for millstones and dimension stone (180 m AOD). The name is first known from a Fountains Abbey manuscript dated 1216 when it was known as 'Brerersty'; by 1496 it had become 'Brasty wod'.

Because the quarry was operative until the late nineteenth century, and still labelled as a millstone quarry on Ordnance Survey mapping surveyed in

Braisty Woods is connected to the nearest road by the stone causeway shown here, which passes the former mill in the distance, but it is not known when it was laid.

1848/9, much of the earlier evidence of quarrying was long since destroyed. Despite this, two early and very large millstones survive near the entrance to the early quarry but both were cracked or broken thus abandoned; both had the eye cut through. The documentary record makes up for a lack of physical remains. In 1502 the magnate Sir John Norton of Sawley, between Braisty and Fountains Abbey, granted to Fountains Abbey all his quarries (*querela*) and millstones with right of passage across his lands; he gave Fountains full and free liberty to open quarries as and where they wished to win stone for use at the abbey and their grange in Brimham.

In the post-Dissolution era (after 1536) Fountains' lands hereabouts passed to Sir William Ingilby of Ripley Castle and in 1600 he entered into an agreement with Thomas Scaife, but reserved to himself rights to 'all Quarries of Stone fitt for making of Millstones ... and Liberty to Search digg gett use have take and Carry away the Same' from Braisty with the cost to Scaife set at 12*d* per pair of millstones; in 1615 his lease was extended. In 1602 Robert Norton paid the Slingsby estate, which was also involved in the millstone quarry, £3 6*s* 11*d* for a 'paire of Mylnestones and charges about the same'. In 1629 payment of £16 was made by the Slingsbys to a miller at Knaresborough

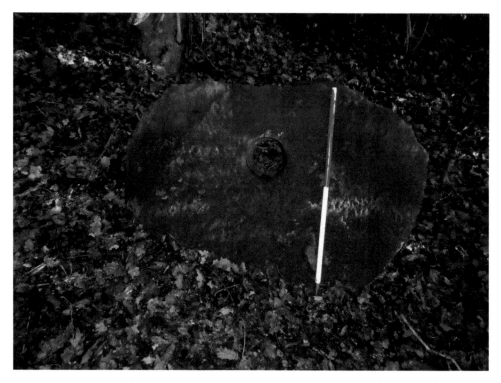

Two millstones managed to survive later large-scale quarrying at Braisty. This one was complete but fractured, possibly while being manhandled. Its diameter is 1.77 m and it is domed – both characteristics of early millstones.

The other is equally massive, being 1.6 m and useless.

for, among other expenses, 'towe paire of millestones bought at Braistie wood and brought to the mille doore'. The millstone quarry remained in the hands of the Ingilbys into the 1720s, though leased out; it was still operative in 1723 but by 1737/8 was described in a newspaper advertisement as the 'old Milstone Quarry at Braisty-Wood ... so well known for the goodness of the Grit at the time it was wrought (which is about 25 years ago)'. This is odd given that the quarry lease had been renewed only fifteen years previously. The advert, lodged by the Ingilby estate, promoted the fact that the quarry had been 'opened anew' with a 'great Number of very good New Grey-Milstones of several Sizes ... now there ready drest and fit for Sale'. A footnote to the advert added, somewhat immodestly, that Braisty was 'the best Grey-Milstone Quarry in the part of the Country it is in'.

Whether it was because of the advert or the fact that the Ingilbys had taken the quarry back in hand, output grew after 1737 and a rare set of accounts (for 1737–50) confirms this. For each month sales were recorded with customer name, number of millstones purchased, diameter of each and purchase cost. Annual output was erratic, as was income. For 1746–50 income totalled £247 4s and outgoings came to £191 1s 1d, giving a profit of £86 2s 11d. Some entries included carriage costs and a significant number also stated the millstones' destination: twenty-four different mills were listed. Braisty Mill was close to the quarry but many millstones were sent far and wide; it is impossible

now to state which precise routes were taken, though it can be assumed that steep inclines were avoided wherever possible. However, apart from going down the river valley, every direction involved a considerable ascent. Wakefield (*c.* 60 km), Leeds (50 km), Richmond (45 km), Witton (35 km), York and Bedale (30 km) and Topcliffe (29 km) were the most distant destinations. Only two were carried less than 5 km, ten were carted 5–20 km, and eleven over 20 km between 1737 and 1750. Common sense might dictate that there was a direct correlation between distance and carriage costs but this is not borne out by the accounts. For example, carriage of two millstones to Spofforth (22 km) cost £2, whereas one sent to Wakefield cost £2 15*s* and one to Leeds cost £6, almost the same as the purchase cost. Two 'little Stones' sent to York in 1740 cost £2 7*s* 6*d* for carriage but two others in the same year cost £4 15*s*. Sets of dry accounts never explain such contradictions.

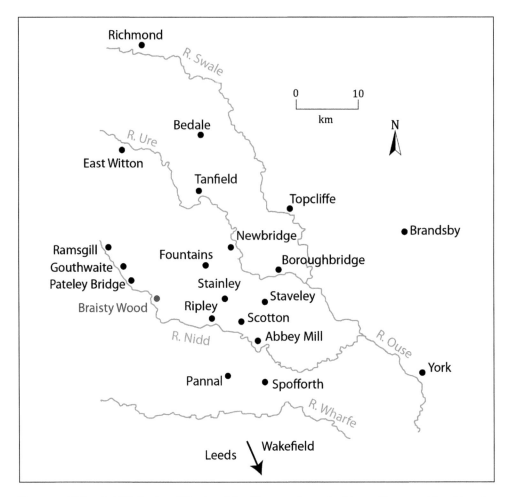

Between 1737 and 1750, Braisty Woods sold millstones far and wide, as illustrated by this sales distribution map.

8

Forest of Bowland

Clougha is a large extent of open fell at the north-western extremity (historically the Forest of Quernmore) of the Forest of Bowland, rising to 413 m AOD. An outlier of the fell is Baines Crag, a small roadside outcrop which has been cut back by quarrying over centuries. One source noted the presence of twenty-three millstone roughouts on or just above the Crag; this survey definitively identified only five, though the quarried area is heavily infested with bracken and is difficult of access. All five confirmed roughouts were in the early production stages and only two had the eye partly cut. Being adjacent to a tarred road, others could easily have been taken away after the site was abandoned.

Across Clougha itself – exploration of which is severely hindered by dense heather cover – millstones were hewn not from rockface but from earthfast

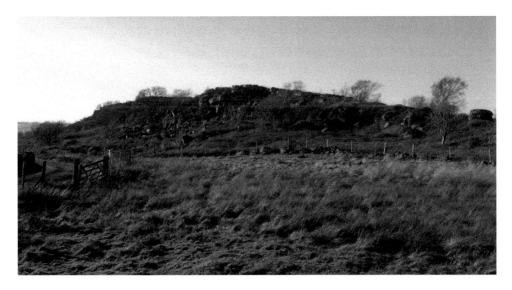

Baines Crag viewed from the south. The natural outcrop was quarried back for millstones and also worked along its rim.

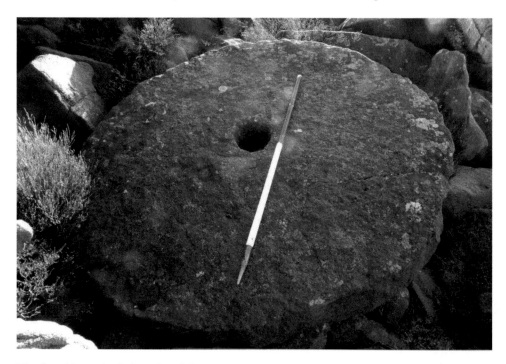

This domed but unfinished roughout below the crag is more likely to be an early than a late example.

boulders or surface outcrops of gritstone, referred to as *daystone* in the industry. Clougha has no single concentration of roughouts; rather they are scattered across the fell sometimes singly, sometimes in small groupings depending on the size of the outcrops. In some instances the roughouts were sourced from within shallow delfs sunk into the ground surface. This is one of the production sites where transporting the completed roughouts off the moor must have proved problematic. It is very rough and broken ground with small streams and it lacks obvious tracks or sledways. Operating at an altitude of up to 400 m AOD would also have proved challenging and this fell has minimal shelter from the prevailing winds.

Early-stage as opposed to advanced roughouts surveyed are in the proportion of two to one on Clougha; only one has the eye fully cut through and only one fractured.

Elsewhere in the western part of the Bowland Fells there are other production nodes, for example at Millers House (nine roughouts) and on Brennand Great Hill (seven), both at or above 400 m AOD. As with all sites in this survey, every stage in the manufacturing process can be identified across the Brennand Fell sites. Thirteen roughouts were in the early stages and only two at or close to completion; two were abandoned because they fractured. Four have the central eye picked out. Tooling evidence was able to locate two further intended roughouts.

Some of the workings were in shallow delfs on the quarry floor including this one, which was only partly shaped.

A view across the bleak expanse of Brennand Great Hill, from which many roughouts were hewn.

This close-up image indicates just how much rock has been removed over the years by stone-getters.

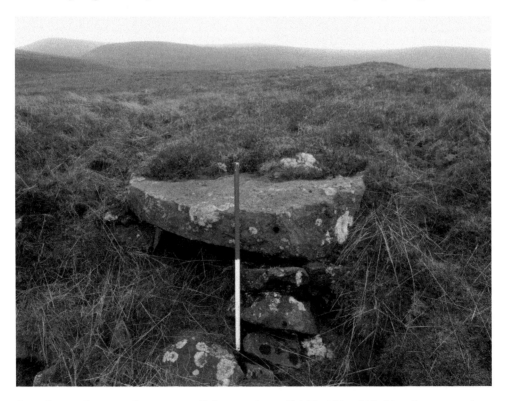

Apart from workings into the outcrop itself, there are also small delfs within which this early-stage roughout was worked to the required thickness on one face only.

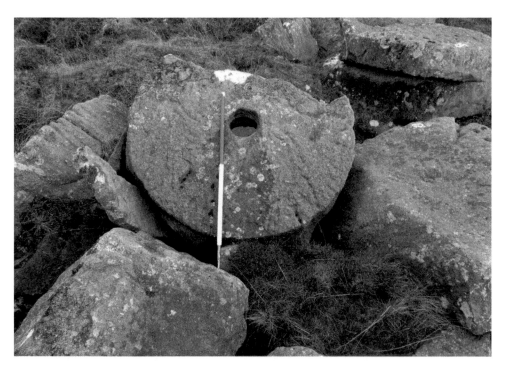

In this focus of work a roughout broke in two after being completed; two others lie to its right and the scalloped edge of a negative is seen to its left.

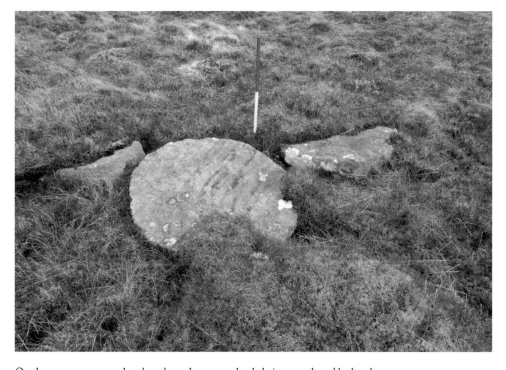

On the open moor two abandoned roughouts are slowly being smothered by heather.

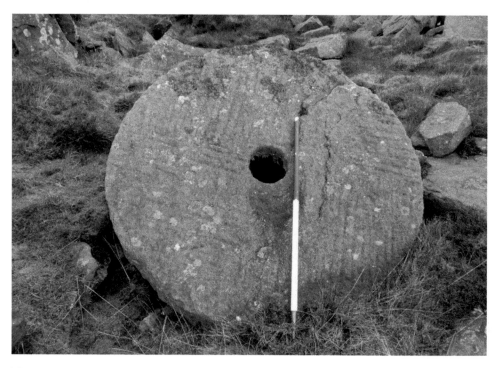

This otherwise completed roughout, with clear peck-dressed tool marks, failed along its upper face at the last minute to the presumed frustration of the hewers.

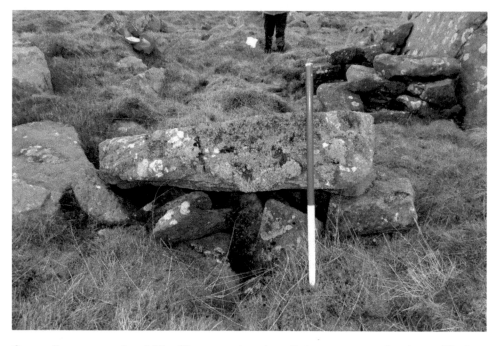

On a small outcrop away from Millers House, several roughouts lie in various stages of production. This large stone was fully tooled on its upper face and was ready to be inverted to permit shaping on the lower side. A worker's open-topped shelter lies just to the right.

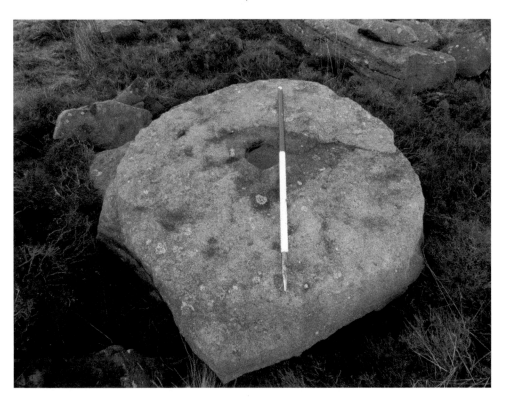

The small size of this early-stage roughout suggests it was intended as an edge runner rather than a millstone. Clearly the eye was cut before work began on shaping the circumference.

The accounts of Henry de Lacy, one of the great magnates of late thirteenth-century North West England, noted that in 1296 a 'rock of millstones' was let for £1 6s 8d per year and it most likely refers to Clougha or Brennand. In 1346 sale of millstones from the Forest of Quernmore raised 1s, which contrasts unfavourably with £13 6s 8d generated by letting herbage and perhaps indicates the uncertainty of millstone production.

Mallerstang, Westmorland

The north–south valley called Mallerstang runs from the North Yorkshire/ Cumbria county boundary at the head of Wensleydale almost to Kirkby Stephen and on both sides it is bounded by steeply rising escarpments. A section along both sides is known as Mallerstang Common. On the eastern side there is an extensive area of periglacial slumping and chaotic spreads of gritstone boulders, especially within Elmgill Crag, nestling below high-level scars – Hangingstone Scar, High and Low Loven Scars and Low Band. In this combined area, ranging in height from 420–640 m AOD, about thirty roughouts were identified in the field survey, displaying every stage in the production process.

Elmgill Scar is not a scar (cliff) at all, rather a long cascading boulder field below Hangingstone Scar. Within the chaos of boulders suitable rocks were selected for millstones.

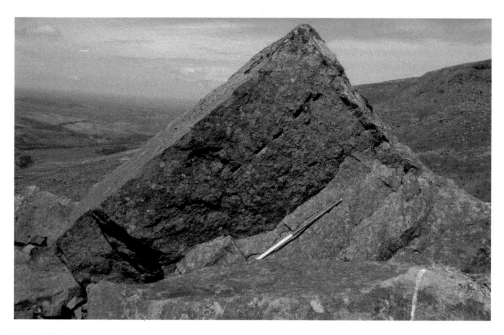

Below High Loven Scar this massive tumbler block was chosen but the hewers got no further than scribing a line of wedge pits to separate the upper part of the block from the rest.

On some blocks, lying at all angles within the boulder field, the initial task was to define the circumference using hammer and chisel. The skill involved in defining a perfect circle on a leaning block is impressive.

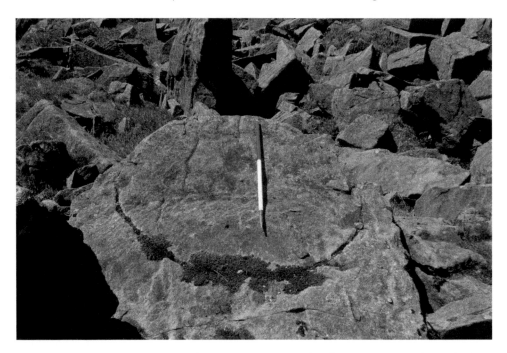

Working on this one was an altogether different proposition as it lies flat; here the circumference has been fully chiselled out.

Even where no roughouts are to be found, there is evidence in the form of negatives, like this telltale 'pastry-cutter' edge.

Some of the evidence is almost awe-inspiring, as here where the upper part of the tumbler has been partially separated from the rest and the outline of the roughout has been defined. This image also illustrates the remoteness of Mallerstang's production sites.

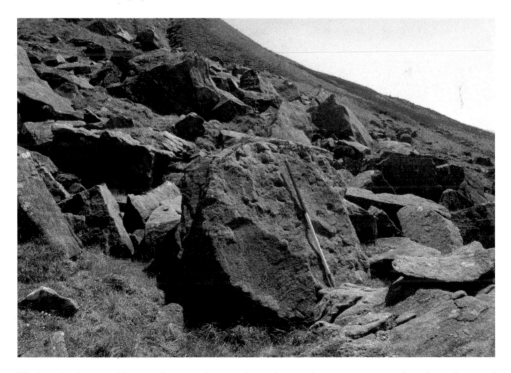

Work on this leaning slab stopped in its early stages but tooling marks are seen on part of its edge and a curved negative lies to the right. Given the size and weight of this block, how would they have moved it to easier ground?

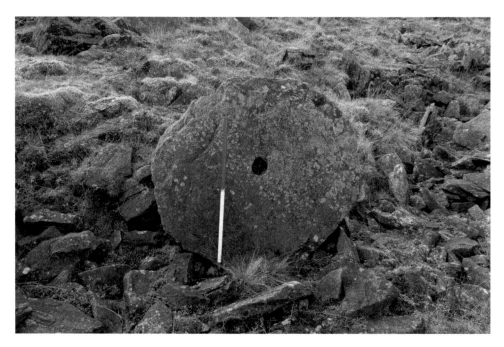

This completed roughout had been stood upright ready for moving off the hill. Its diameter is 1.55 m but it is very thin compared to most. Such stones were used in tandem in corn mills to separate the husk from the inner grain (or *groat*) prior to feeding the hulled grain through the actual milling stones.

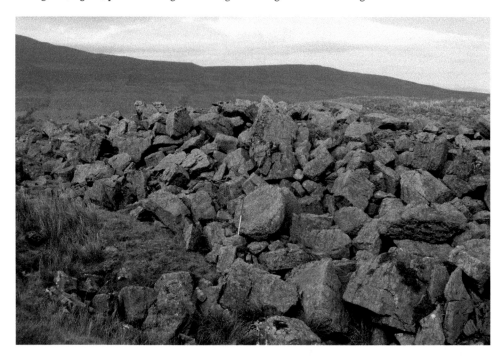

The block behind the pole was selected and some work shaping the upper part of the circumference had begun. In order to fully work this one, the workers would need to have moved it out of the boulder field onto easier ground. At 1.5 m diameter and also very thick in its present state, it would have weighed over half a ton.

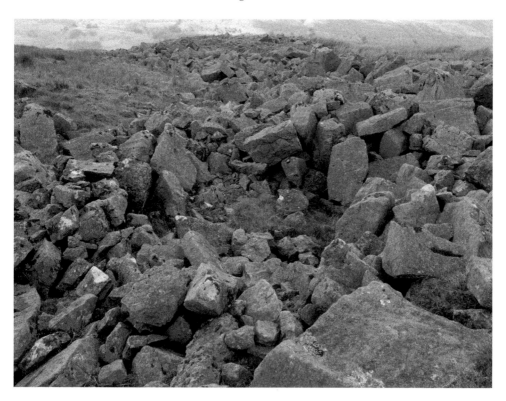

This image looks downhill within Elmgill Scar and in the centre is an area cleared of rock. Evidence within it shows that at least one roughout had been removed and, yet again, how they did it on such hostile ground defies explanation.

Production sites have also been identified around Wild Boar Fell, specifically between Blackbed Scar and Yoadcomb Hill with over twenty roughouts, but also on The Band (four roughouts), below High and Low White Scars, and between the summit plateau and Sand Tarn. The altitudinal range of workings on the hill is 570–700 m AOD.

Close examination of these production sites illustrates well every stage in the process from choosing a potentially suitable piece of rock to final tooling and preparation for despatch. It also highlights the difficulties of working in such hostile terrain, as well as the challenges faced in getting the roughouts out of the boulder fields never mind off the hill. Several lie abandoned across the lower grassy slopes: presumably they were set off rolling and came to rest and for whatever reason were not recovered. These two areas also show the futility in trying to establish a sequence of steps, leading to the creation of a finished roughout, which is applicable across all production areas. It is clear that different sites – or different masons and hewers – had their own way of going about it. Even within these two sites the strategy varied but there is no means of determining if this is a reflection of different workers or different time periods.

The eastern side of Wild Boar Fell's summit plateau is edged with boulder fields, as seen here on Yoadcomb Hill. It was within these that roughouts were shaped.

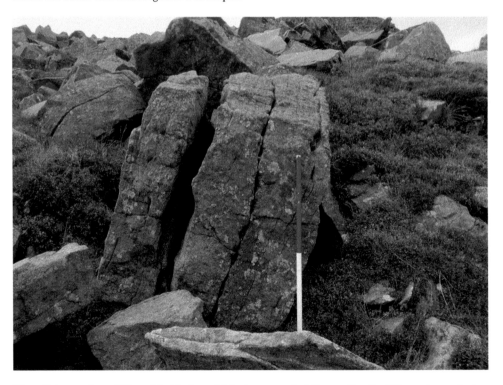

Three distinct sections of this upright block are visible: the one on the left naturally split off the rest by weathering, but the line of wedge pits between the central and right-hand parts shows that work on a roughout had begun.

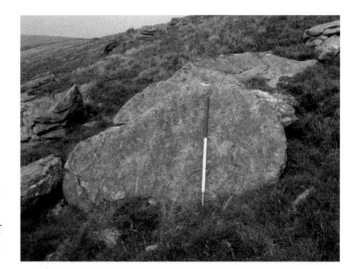

Partway downhill on the south-facing side of the massif, work had begun to shape the circumference of this earthfast slab of gritstone. To the right of the pole, tooling marks are seen on the edge.

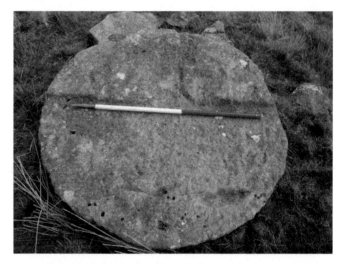

On this small (edge-runner) block, the part below the pole and where red meets white above it had been pecked down to the required depth before work stopped.

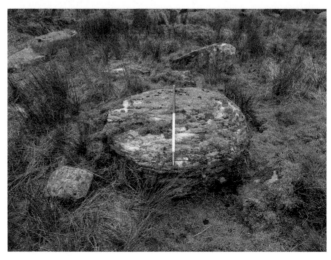

This small stone was also being shaped as an edge runner and the upper part seems to have been finished, though it needed upturning to chisel away the lower part.

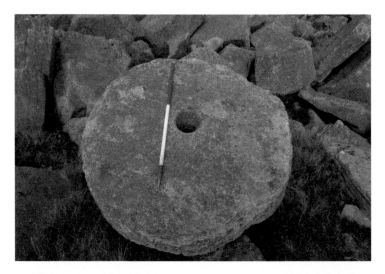

This roughout was almost complete and only the bottom part needed to be fully shaped.

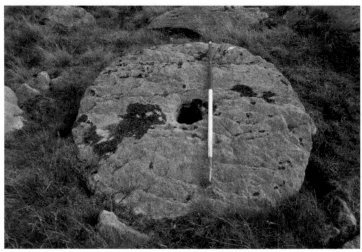

Comparing this one with the previous stone, it is obvious that much more work was needed to smooth off its face.

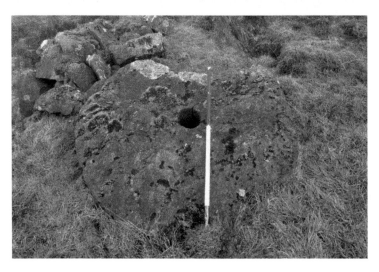

One has to feel compassion for the hewers who toiled on this large, domed roughout on the slopes above Sand Tarn on the west side of Wild Boar Fell. It was complete but broke.

Right: This large example illustrates well how the millpickers roughed out millstones: clear pick-dressing marks cover the entire face.

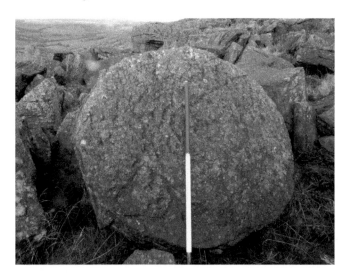

Below: Back on Yoadcomb Hill, this chaos of boulders hides two abandoned roughouts and evidence of working is apparent in the bottom left-hand corner of the image; time and again, one has to wonder how they were extracted.

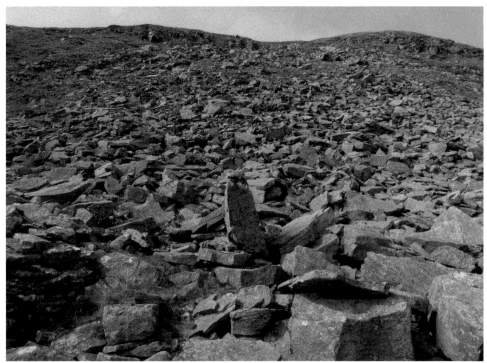

These sites also have variations in how shelters were constructed, from crude open-topped windbreaks to sophisticated structures with a corbelled roof.

Despite the sheer scale of the enterprise in Mallerstang, there is a surprising lack of records. Lady Anne Clifford held sway over much of Mallerstang, and Bongate (corn) Mill in Appleby was a manorial possession; her surviving account books for 1665 and 1667/8 include payments for millstones for Bongate and other corn mills at Brougham and Brough Sowerby. One

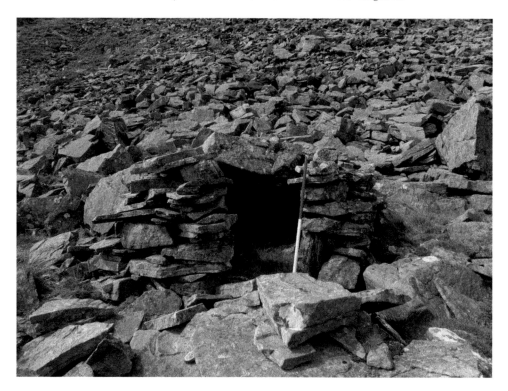

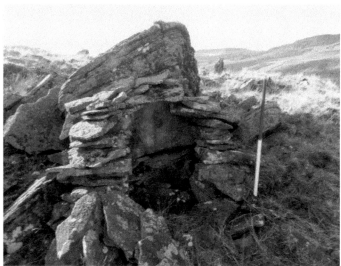

Above: What was glimpsed in the corner of the previous image is a one-person shelter with a corbelled roof. It faces south-east away from the prevailing winds.

Left: On Elmgill Crag, in contrast, whoever worked here had only this crude, open-topped shelter for protection.

such Bongate stone was sourced in 1668 from 'Whinfields' (now Whinfell Forest) east of Penrith; two pairs of stones in 1665 for Brougham from 'my Ground on Stainmoor'; a pair destined for Brough Sowerby in 1665, though their source was not stated; and yet another pair for Bongate in 1665 from 'Loven Scarre'. This last entry is the only located record of millstone sales from Mallerstang.

Stainmore and Nine Standards

Millstones were sourced from several gritstone outcrops in Stainmore on or just west of the main North Pennine watershed. South of the cross-Pennine A66 they were produced on Brough Sowerby Common and at Mousegill Quarry, but no ground evidence has survived. North of the A66 there is evidence on two sites: a low ridge called Millstone Band on Stainmore Common has seven early-stage roughouts, two of which were abandoned when they fractured, and a shelter; while West Dow Crag, a prominent scar along the northern edge of Iron Band, has two early-stage and two advanced roughouts.

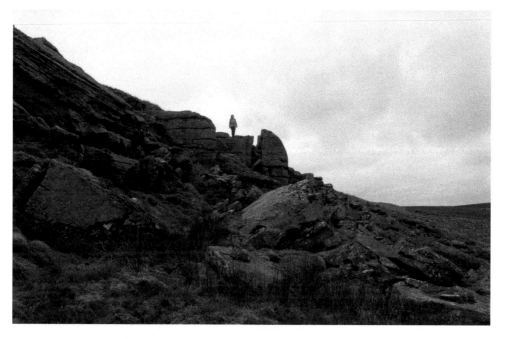

The outcrop on the edge of West Dow Crag in Stainmore was worked for millstones though no documentary evidence has been sourced. The nearest road, to the north, is over 1 km across very boggy ground.

South of Stainmore there is ground evidence of millstone working across the Nine Standards Rigg massif. Two early-stage roughouts lie abandoned near the summit and telltale tooling marks are seen there and on a Millstone Rigg outcrop.

These production sites cause head scratching for the discerning observer. Workings across Nine Standards lie between the 620 and 65 0m contours with those in North Stainmore on the 470 m and 560 m contours. All of them are in a landscape dominated by deep deposits of peat frequently punctuated by bog,

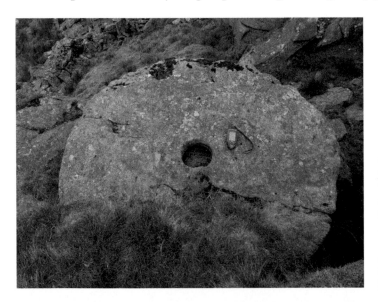

Left: This millstone was almost complete on the upper face, but frustratingly a major crack caused it to be abandoned.

Below: This one was even more complete but split in two in its final stages.

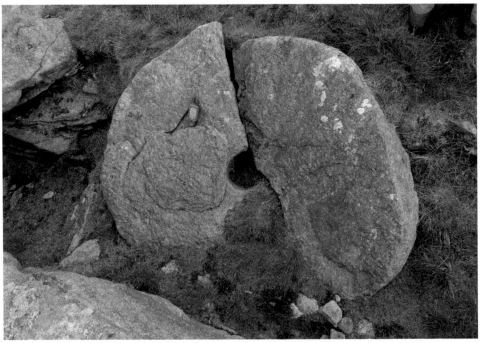

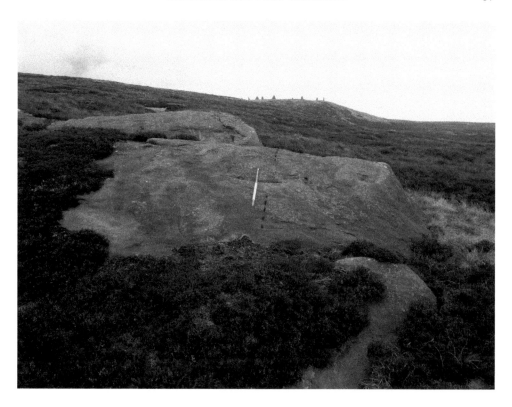

Above: Several outcrops were worked around Nine Standards Rigg south of Stainmore. Work had begun on this bedrock slab picking out a line of wedge pits to split it into two. The nine 'standards' (stone columns) are seen on the skyline.

Right: This pile of rocks, one showing a clear scalloped edge, is the residue of a removed roughout.

deep groughs and steep-sided haggs. The shortest way off the Nine Standards sites, heading southwards, is 3 km; that from Millstone Band is almost the same. The logistics involved are difficult to comprehend. Working conditions must have been horrendous at times: at least Millstone Band had a simple (but open-topped) shelter close by.

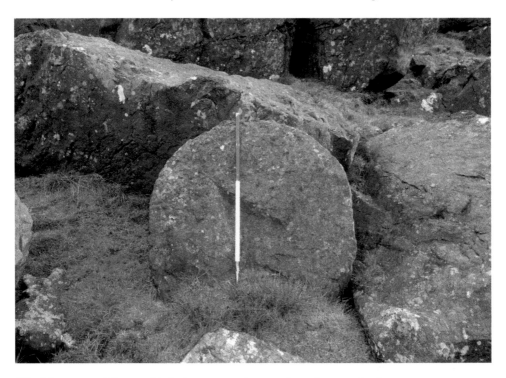

This slab was set upright to enable the hewers to work on one face prior to turning it over.

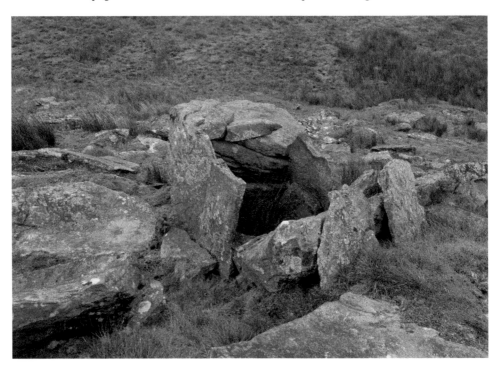

Millstone Band in North Stainmore is a 450-metre-long ridge where millstones were sourced. Nestling close to the edge is an open-topped shelter formed of slabs of rock set upright, but roofless.

Woodhall Greets, Wensleydale

Woodhall Greets is an expanse of moorland on the northern side of Wensleydale, above Askrigg. Along the southern edge of the moor an 800-metre-long low scar – Greets Edge – runs between the 520 m and 530 m contours. At the foot of the scar, on the upper rim, and on the scar itself is a series of seventeen roughouts in various stages of production as well as the usual tooling marks on loose or earthfast rock.

The archival record is restricted to the early eighteenth century, though ground evidence points to millstone working from a much earlier period.

Above and among the gritstone Greets Edge there is ground and documentary evidence of widespread millstone production with roughouts scattered among the rocks below and on surface outcrops along the rim.

Widespread debris at the foot of the edge indicates where roughouts were hewn and removed.

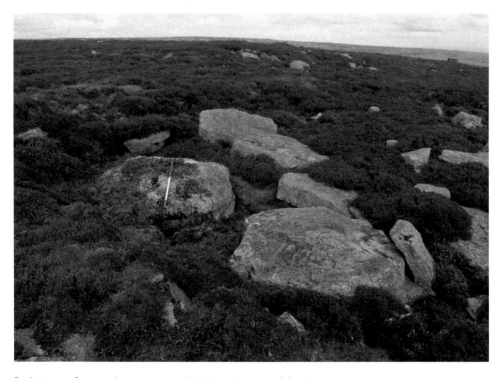

In this image four roughouts are seen, all in the early stages of shaping.

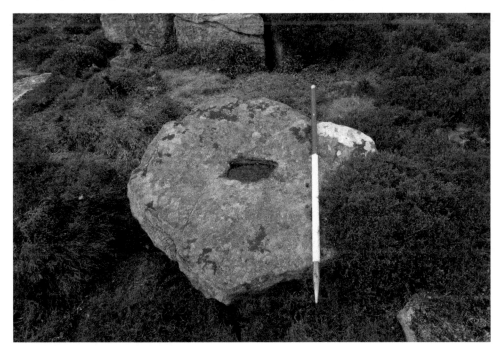

A very early-stage roughout with some tooling evidence visible on the top edge.

Another early-stage roughout with the eye cut partway through.

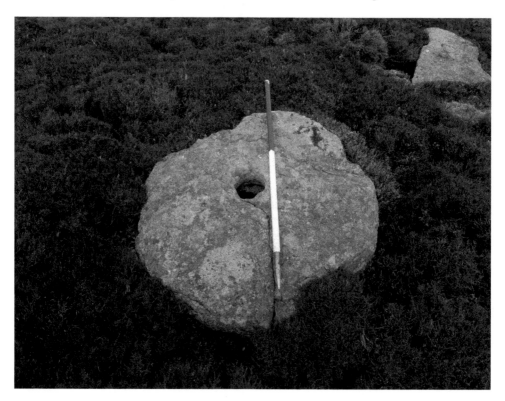

This one had the eye cut but it cracked as the hewers were at work, so it was abandoned.

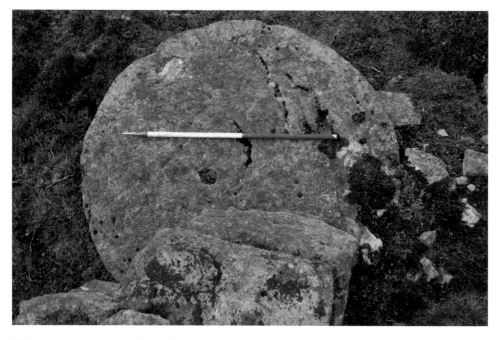

Unlike some other stones on Greets, this one was essentially complete though without the eye. It is impossible now to understand why different processes were adopted on the same site.

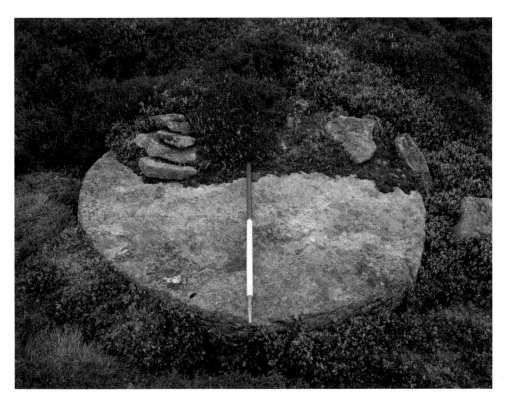

This roughout was even more advanced but also has no eye.

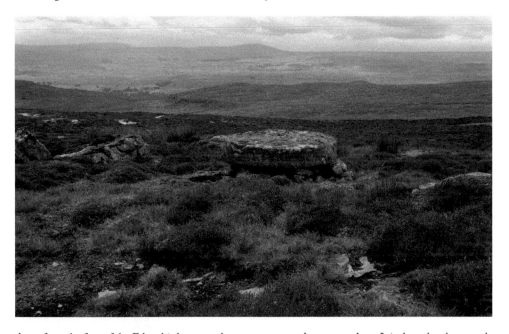

Away from the foot of the Edge this large roughout was supported on a stone base. It is domed and was ready to be sent off the hill but developed a crack on one part of the circumference. If used in a mill, it would have sheared with potentially disastrous consequences for the miller – it had to be discarded.

Like many production sites, Greets is exposed to the weather despite the crag providing some relief from northerly winds for men working below it. Two shelters nestle against the crag, which would have protected the workers from the north wind.

At the turn of the eighteenth century Greets lay within Worton estate, which had manorial corn mills at Askrigg and Bainbridge. In 1701/2 both mills were renovated and the sum of 15s 6d was disbursed to three men, on 28 September 1702, for leading a 'great Milnstone and a runner ... from Woodhall Moor October first' to Bainbridge. On 9 October 1703 two men were paid for leading a millstone a few months previously – whether this was part of the original renovation is not indicated. On 13 August 1745 £13 6s 9d was expended on a new millstone supplied to Bainbridge the previous year, suggesting the millstones installed in 1702/3 had been worn beyond repair.

From Greets to Askrigg's Low Mill on Paddock Beck is only 4 km, with much of it by road, and to Bainbridge – which had two corn mills on the River Bain – entailed an extra 3 km, again on roads, so it would have been possible to transport the roughouts from Greets by horse- or ox-drawn wagons.

Backtracking a little, on 20 December 1714 the estate leased both mills to new tenants, Mr Bryant and Stephen Moor, and undertook to supply the mills with a 'pair of blew stones'. This entry is of significance. Millstones made

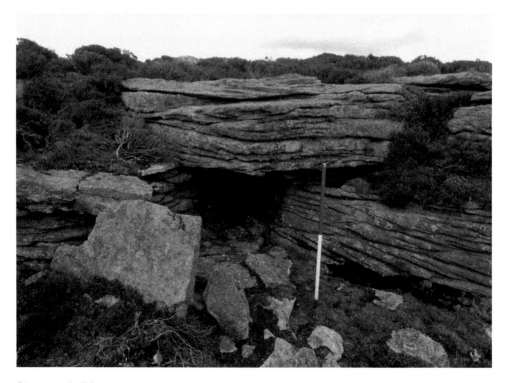

Set against the Edge is this crude one-person shelter, but without a roof it provided little protection against rain.

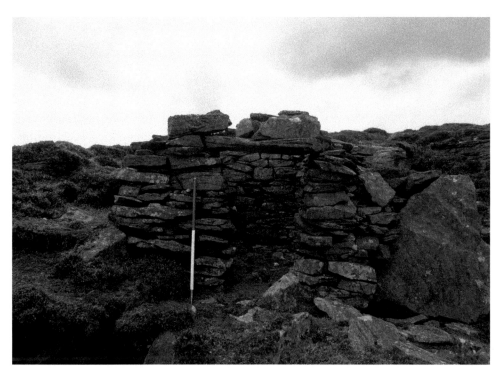

Elsewhere among these workings is this much more sensible two-person roofed shelter.

from coarse-grained Millstone Grit were widely known as grey stones but, as time went on, they were perceived as being unsuitable for grinding wheat (as opposed to oats, barley or maslin). From the early 1700s, at the latest, 'blue' millstones made from hard, fine-grained basalt in Rhineland were imported into England for milling wheat flour. That Bryant and/or Moor were aware of blue stones at this early date, and that the estate was prepared to foot the cost of imported stones rather than ones sourced from its own lands, implies they (if these two men were the actual millers) were well versed in their craft.

In 1798 the operators of Bainbridge Mill purchased two 'grey stones' from Millstone Lumps on Addingham Moor, an extraordinary journey of over 60 km especially in midwinter when they were bought; this mill used two pairs of millstones, the other pair being blue stones, possibly those purchased in 1714.

Edge Runners and Grindstones

Given the historical demand for grindstones and edge runners for the purposes described earlier, it makes sense that these were roughed out across Pennine production sites, and several quarries and moorland sites produced them well into the twentieth century.

Grindstones, scythe-sharpening stones and holystones were produced at Ackworth, south-east of Wakefield just outside the survey area, from the issue

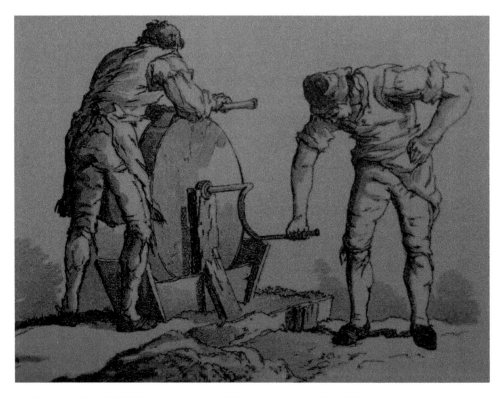

An illustration from 1808 of sharpening an axe blade on a grindstone. (Pyne, Plate 24)

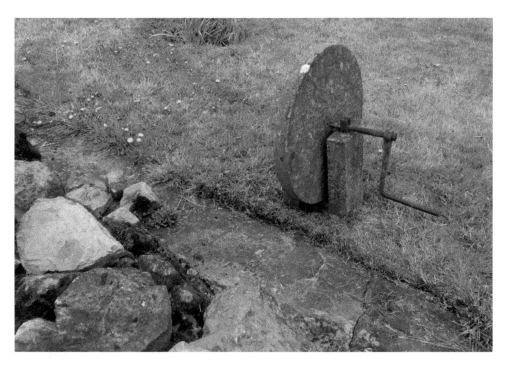

A grindstone preserved on a farm in Malhamdale in its original frame. These were ubiquitous in all rural areas.

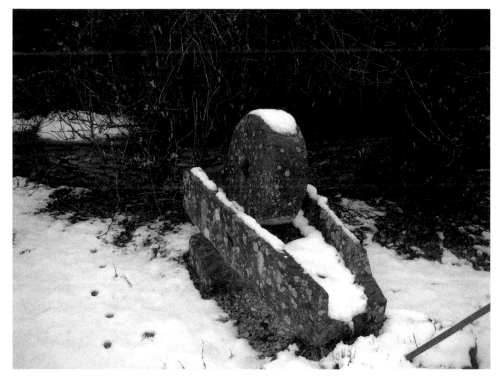

A pulping-stone edge runner in its original stone trough.

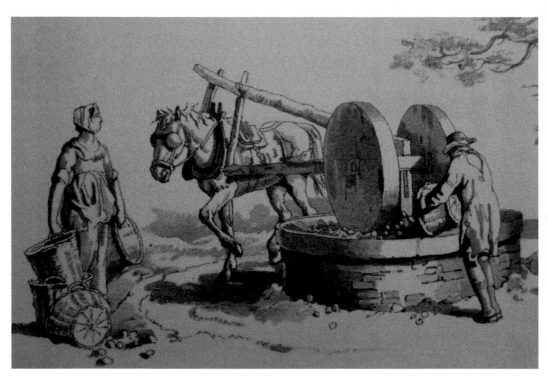

'Bruising' apples using twin horse-powered pulping stones as part of the cider-making process.

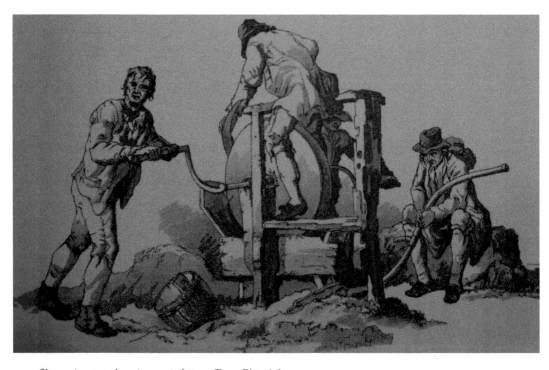

Sharpening a scythe using a grindstone. (Pyne, Plate 24).

of a royal charter in 1629 until 1970, supplying markets all over England and overseas till the mid-nineteenth century.

At the now-landscaped Law Hill Quarry, north-east of Colne (Lancashire), there was a major nineteenth- and early twentieth-century operation producing pulping grindstones for export via Liverpool to Canada and Norway; while Calverley Woods, in the Lower Aire valley, turned its attention from millstones to grindstones in the nineteenth century. Small edge runners were also roughed out on Embsay Moor.

Nidderdale was a significant producer of grindstones and edge runners with several quarries operative into the 1930s. Hope Quarry (Dacre), for example, was leased from the Ingilby estate by Arthur Thackray, of Kirkstall

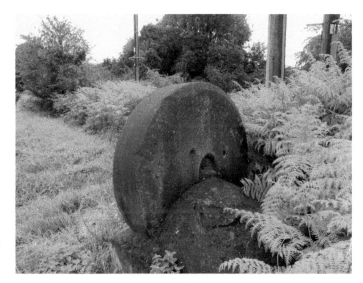

A grindstone preserved as a nameplate at the entry to Ackworth, Wakefield, which was a major long-term producer.

A small edge runner in its original delf on Embsay Moor. (200-mm scale).

(Leeds) from 1904 producing grindstones of 1.3–1.5 m diameter and 300 mm thickness. He worked it till his death in 1932, after which his wife carried on the business until 1936. It was then bought by a Colne-based business (maybe the Law Hill one), which concentrated on pulping stones using a trepanner to create the circularity of the stones (diameters up to 1.8 m). Hope Quarry ceased operations in 1939.

Further up Nidderdale, at Middle Tongue Quarry (Bewerley), Jonathan and Ackroyd Jennings, stone merchants, leased the quarry for twenty-one years to produce large wood-pulping stones which they finished off at their works in Pateley Bridge prior to export to Canada and Scandinavia. It is unlikely it operated beyond the early 1930s.

The Wensleydale Grindstone Company worked Laverock Quarry on Barden Moor (Catterick) for 'good reliable, even, and safe' grindstones – or 'file grinders', which sold for £1 less than their competitors.

Moulds Top is the eastern side of extensive moorland lying to the west of Arkengarthdale at an altitude of nearly 500 m AOD; it was heavily affected by mining operations for both lead and chert, but was also worked for millstones and grindstones. Fourteen roughouts were logged in this survey, as well as other outcrops with telltale tooling marks. Accounts for 1465/6 specify 'Milnestandrig' and for 1473/4 'Milnstanderage' within Arkengarthdale manor: Both translate as 'millstone ridge'. In 1494 Molderset Quarry was let

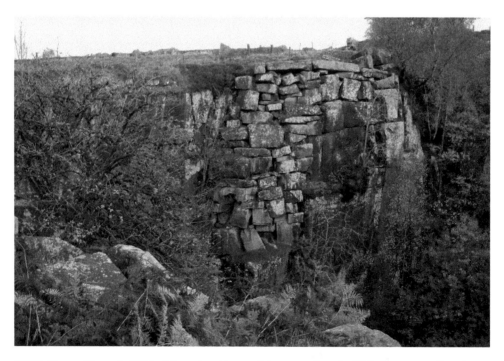

Middle Tongue Quarry in Nidderdale produced large pulping stones into the 1930s for export to Canada.

for the getting of millstones at an annual rent of 4s; 'Molder' is an early form of 'Mould'. Whereas millstones were roughed out here from the Middle Ages, grindstone production was more recent. Roughouts were sent by horse-drawn wagons, and later by motor lorries, to the railway station at Richmond for onward despatch to Tyneside. This mill ground flint, used as glaze in the pottery industry, which was imported by sea and river from South East England in the eighteenth and nineteenth centuries, probably in part as ballast on colliers returning north.

Right: A grindstone roughout seen on Hungry Hushes, Arkengarthdale, repurposed as a grouse feeding station.

Below: Grindstones from Hungry Hushes were despatched to Jesmond Flint Mill in Newcastle-upon-Tyne for crushing flint for use in the ceramics industry.

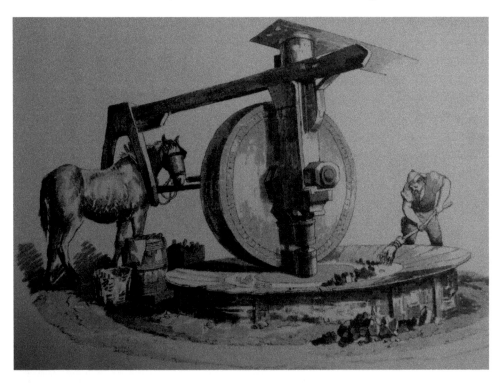

Flint was pulverised using grindstones like this one. (Pyne, Plate 22).

Barrowfield Quarry in the South Lakes produced limestone grindstones for use in local gunpowder mills.

Grindstones were manufactured on several sites in south Cumbria, exploiting limestone, for local gunpowder works. Low Wood Gunpowder Works at Backbarrow, operative from 1798 to 1935 with six pairs of water-powered grindstones, sourced its stones from a quarry in Barrowfield Wood (Underbarrow). All of the stones lying within the disused Works are 2.2 m in diameter with a thickness of 440 mm. Gritstone and sandstone were not suitable because the slightest spark when mixing saltpetre, charcoal and sulphur meant catastrophe; limestone gave off no sparks. At the end of a trackway leading to Gillbirks Quarry on Whitbarrow an abandoned limestone grindstone, propped on a timber support ready for loading, measures 2.14 m across by 550 mm.

Elsewhere in Cumbria outcrops of Penrith Sandstone were exploited for edge runners.

Other limestone grindstones were sourced from Gilbirks Quarry, Whitbarrow, in the South Lakes. This one (2.14 m by 550 mm) was ready to be collected, but for whatever reason was not.

Within the remains of Low Wood Gunpowder Works at Haverthwaite on the River Leven there are several grindstones such as this one. Some are 1.75 m by 580 mm, others are 2.2 m by 440 mm. Six pairs were operational at any given time.

13

Legacy

Dating Production Sites

We have seen so far that archaeology and written sources help to place some of the production sites in a loose chronological order. The earliest workings on the six sites with domed 'mushroom' roughouts can probably be assumed to be medieval. It is also most likely that sites such as below Hangingstone Scar, the south-eastern side of Wild Boar Fell, Black Coppice and Millstone Lumps indicate a long continuum of millstone working: roughouts sourced from crag faces will relate to the latest phase of operation whereas those within the boulder fields predate them. In turn, evidence of production – either as abandoned roughouts or clear tooling marks – below the boulder fields is probably even earlier. Shallow delfs within which millstones were hewn from buried bedrock or small surface outcrops or earthfast rock may well represent the earliest phase. Early masons and millpickers in search of suitable rock would surely have selected what was easiest to access. On Embsay Moor three elements suggest millstones were worked in the medieval era. First, much of the moor is pockmarked with small delfs and associated (vegetated) debris mounds – a classic medieval 'hills and hollows' quarried landscape. Second, only one of the eleven roughouts lying abandoned on this moor has a diameter greater than 1 m, but only by 100 mm; the others range from 750 to 900 mm. It is thought that many 'early' millstones often had a diameter as small as 760 mm. Third, there is documentary evidence from the medieval era of stone extraction on *Stanerig* intended for repairs to Skipton Castle. Stone Ridge is the pockmarked part of the moor.

We can add, with an element of caution, a further indicator of age. Millpickers presumably took time off during their working day and there is evidence they did not sit idly by but left their mark on the landscape as graffiti. Arguably some could have been carved by shepherds, though their position among worked stone

suggests otherwise. As examples, on an earthfast rock on Elmgill Scar are the initials 'R.M.'; on a rockface adjacent to a roughout on West Dow Crag are 'T' and 'GB'; next to the smithy below Millstone Lumps crag are several sets of initials – 'PF', 'RT' and 'PS 175-'; on a slab next to a roughout on Summer Lodge Moor, Swaledale, is 'J.171-'; and on a face among the workings on Whelp Stone Crag in Bowland is 'TR . FEB . 7 . 18' (i.e. 7 February 1718 – or maybe 78). Inscriptions such as these lend an element of humanity to this lost industry. We will never know who T or PF or TR were but they clearly felt the urge to leave their mark on the place where they had presumably spent part of their working life.

Etched into an earthfast slab of rock on the edge of Elmgill Crag are the initials R.M. He was probably a stonegetter.

Next to a roughout forlornly awaiting collection by the roadside on Summer Lodge Moor the initials J.171(7?) were etched, again presumably by a stonegetter.

Heritage

It is common across the country to find that signs of past industrial glory have been swept away, as if later generations were ashamed of what their forebears had done for a living, but it is heartening to see that the canal basin at Whittle-le-Woods has been partly preserved with local millstone roughouts arranged as a fitting memorial to past endeavour. Millstones from here were sent down the specially constructed southern branch of the Lancaster Canal from 1816, though production was underway from at least 1666, when each millstone sold for 13*s* 4*d*. This canal linked to the Leeds & Liverpool Canal and millstones were exported from Liverpool worldwide, such was their reputation for quality.

This industry's legacy is also preserved by evidence seen on the ground – abandoned roughouts, part-worked roughouts, negatives, tooling marks, primitive shelters – and who knows how many roughouts each site produced in its operational lifetime. The number peppered across the moors today must be a mere fraction of what was produced; equally, there is no way of knowing what overall proportion of roughouts had to be abandoned because they cracked or broke in two.

The importance and longevity of millstone making at Whittle-le-Woods is perpetuated by this pleasing arrangement of four millstones at the former canal basin. Their diameters range from 1.23 to 1.8 m and edge thicknesses from 150 to 300 mm. Two are domed.

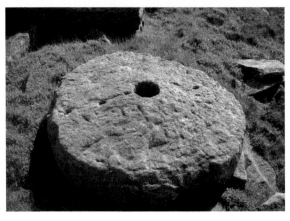

Abandoned roughouts are a fitting testament to a lost industry, even though this was never intentional. A superb example lies on the Pen-y-ghent Side summit plateau in the Yorkshire Dales. It was completed, is 1.5 m in diameter and 350 mm thick at the edge.

In the past the majority of people relied on local corn mills to grind their grain into flour. There is a direct parallel here. No grain ... no flour ... no bread ... hunger. As we saw at the beginning of the book, there were thousands of corn mills across England, never mind in Scotland and Wales, all meeting the basic needs of local people.

The vast majority of these mills no longer exist or have been converted to other uses, industrial or residential. Some lie disused and decaying. A small minority still operate at a small scale milling flour and/or open to the public as visitor attractions. In the survey area accessible working mills include:

Acorn Bank Mill near Penrith (NY614283), managed by the National Trust
Boot Mill in Eskdale in Cumbria (NY176011)
Gleaston Mill near Ulverston in Furness (SD260709)
Heron Corn Mill near Milnthorpe (SD496800)
Little Salkeld Mill in the Eden Valley, Cumbria (NY567360)
Warwick Bridge Mill, east of Carlisle (NY474569)
Wath Mill, Darley, in Nidderdale (SE146678)

All have a dedicated website with a historical overview and are well worth a visit. All help to keep this centuries-old industry alive and functioning.

The legacy is perpetuated in other ways, too. It is not uncommon in localities that had a corn mill to find old millstones leaning against walls or otherwise acting as reminders of the past; and one late nineteenth-century artist, W.H. Mander, created a significant portfolio of paintings of former water mills, especially in Wales.

The long-disused Maulds Meaburn corn mill on the River Lyvennet in Westmorland has a datestone, '1690'. In the garden there are two cullen (blue) millstones and one made from Shap Granite.

Above and below: The former High Town estate corn mill at Dunham Massey, Cheshire, is still operational as a sawmill and three millstones are preserved as mementos of its former function. The largest one is 1.5 m in diameter and is domed with thickness ranging from 170 to 290 mm. The middle one, with '1666' etched into it, is 1.15 m by 170–230, thus also domed. The smallest is 900 mm by 230 mm. This was a barley crusher.

There has been a corn mill at Boot, Eskdale, since at least 1294 and it functioned until 1930. It was restored and reopened as a heritage attraction in 1976, a function it still provides today.

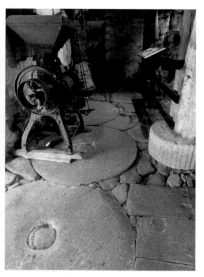

Above left and above right: Over the decades judicious management saw worn-out millstones repurposed as flooring slabs within the ground-floor machinery room. One pair of working millstones is French burrstone, the other Peak District gritstone.

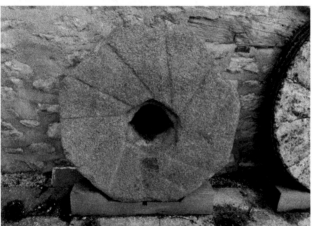

Above and left: There has been a corn mill on the River Bela at Beetham, north of Lancaster, since about 1096, though the present mill was constructed in 1740. It stopped milling grain for human consumption in the 1920s but continued producing animal feed until closure in 1958. It was rescued, restored and opened as a heritage facility in 1975 and now mills wheat, rye and spelt. It has four pairs of millstones – two greystones, and two burrstones purchased in 1849.

The two corn mills still stand in Bainbridge, Wensleydale, but neither is operational. A burrstone stands outside the northern mill, as a memento, and this monolithic greystone has been preserved on the village green as a heritage feature.

It is extremely difficult to find a still standing corn mill as well as a contemporary portrait of it in full use. The ruins of Pandy Mill on the Afon Arran near Dolgellau in North Wales still stand (SH73021707).

Between 1899 and 1904 the notable landscape painter, W.H. Mander captured Pandy Mill during its working life. His painting is entitled *The Old Mill at Dolgelly*. A discarded millstone is seen in the river, bottom right.

Decline

So, why did millstone production in the Pennines and North West England come to an end? One major reason was the increasing imports of burrstones. Originally brought across the Channel in the sixteenth century, they only became prominent in the 1720s. Rather than being heavy monolithic millstones like almost all British-sourced ones, burrstones came in small segments. They were – initially at least – more expensive than British grey stones but they lasted longer and ground a finer flour. It has been estimated that, between 1877 and 1900, a thousand burrstones were shipped into Britain each year. However, by 1809 burrstones were already negatively impacting on demand for grey stones. The change in consumer taste for white rather than discoloured flour and the resulting fall in demand for grey stones were major factors in the decline of home-grown production.

Grey stones could not mill high-quality white flour from wheat, though they are still used for milling oats. Imports of cheap roll-milled white flour from North America after *c.* 1850 probably had a greater negative effect than burrstones, but a smaller effect than the late 1860s/early 1870s introduction of roller mills to Britain. Countless small local corn mills fell victim to centralised roller mills. As with so many rural trades, millstone production lost out to mechanisation, new technology, increased efficiency and economies of scale. It may also be the case that post-1800 generations of young workers were no longer prepared to put up with a harsh way of life with low pay; it is equally likely that developments in roads and later the rail network added another nail in the millstone coffin. Unless (accessible) production sites could turn their attention to producing grindstones, overseas demand for which remained buoyant into the 1930s, millpickers, masons and dressers had no future.

This writer has gone on record describing rural lime burning as the Cinderella of industrial archaeology; maybe Cinderella had a hitherto unknown (non-ugly) sister. Hewers and millpickers worked away in mostly remote locations difficult of access and far from habitation and toiled in often gruelling conditions, exposed to the worst upland weather that could be thrown at them. They must not be seen as unskilled labourers but as highly skilled artisans. They deserve to be remembered and their legacy should be cherished: the millstone industry should stand proud alongside the other, lime burning, Cinderella in the pantheon of Britain's industrial past.

Further Reading

For general accounts of millstone production see J. Langdon, *Mills in the Medieval Economy. England 1300–1540* (Oxford, 2004); D. Gordon Tucker, 'Millstones, quarries and millstone-makers', *Post-Medieval Archaeology* (2, 1977, pp. 1–21); and D.L. Farmer 'Millstones for medieval manors', *Agricultural History Review* (2, 1992, pp. 97–111). For analyses of the industry elsewhere in the British Isles, good introductions include D. Gordon Tucker, 'Millstone making in the Peak District of Derbyshire: the quarries and the technology', *Industrial Archaeology Review* (8, 1985, pp. 42–58); G. Jobey, 'Millstones and millstone quarries in Northumberland', *Archaeologia Aeliana* (14, 1986, pp. 49–80); Tucker, 'Millstone making in Scotland', *Proceedings of the Society of Antiquaries of Scotland* (114, 1984, pp. 539–56); and N. Colfer, 'Turning stone into bread: the millstone quarries of medieval and post-medieval Ireland', *Journal of the Mining Heritage Trust of Ireland* (17, 2019, pp. 31–39). The only detailed account of millstone production within the current survey area is P. Hudson 'Old mills, gritstone quarries and millstone making in the Forest of Lancaster' *Contrebis* (8, 1980, pp. 35–60). The guidebooks for Eskdale and Heron Corn Mills are recommended for their explanations of how millstones operated.

Estate papers and national state papers have been widely consulted for this book, available by searching databases of the relevant county record offices and The National Archives.

For W.H. Pyne's wonderful drawings, see his *Microcosm: or, a Picturesque Delineation of the Arts, Agriculture, Manufactures, etc of Great Britain in a Series of Six Hundred Groups of Small Figures for the Embellishment of Landscape. Part 1 Early Trades and Industries* (London, 1808).

Confirmed Production Sites

Abbotside Common, Yorkshire Dales	SD877935
Baildon Bank, Baildon, West Yorkshire	SE148387
Baines Crag, Bowland, Lancashire	SD543617
Barngill Quarry, Distington, Cumbria	NX998218
Barrowfield Wood, Underbarrow, Cumbria	SD483923
Black Coppice, Anglezarke, Lancashire	SD620186
Black Hills, Cottingley, West Yorkshire	SE099377
Blaze Fell, Hesket, Cumbria	NY495433
Bracken Hill, Ackworth, West Yorkshire	E426167
Braisty Woods, Nidderdale	SE202635
Brennand Fell, Bowland, Lancashire	SD6255
Brough Sowerby Common, Cumbria	NY8112
Buck Wood, Bradford	SE173395
Calverley Wood, Airedale, West Yorkshire	SE205376
Clougha, Bowland, Lancashire	SD5459/60
Cragg Wood, Rawdon	SE206 388
Dole House, Pendle, Lancashire	SD837394
Duxon Hill, Houghton, Lancashire	SD611256
Embsay Moor, Yorkshire Dales	SD992557
Gillbirks Quarry, Whitbarrow, Cumbria	SD452881
Gragareth, Kingsdale, Yorkshire Dales	SD694803
Great Whernside, Wharfedale	SD998770
Hangingstone Scar, Mallerstang, Cumbria	SD794997
Heber's Ghyll, Lower Wharfedale	SE096473
Hope Quarry, Dacre, Nidderdale	SE179607
Idle, Bradford, West Yorkshire	SE1737
Ingleborough, Yorkshire Dales	SD739745
Kellet, Lancashire	SD5068

Laverock Quarry, Catterick, Yorkshire Dales	SE150958
Law Hill Quarry, Colne, Lancashire	SD908412
Lazonby Fell, Cumbria	NY517382
Little Ingleborough, Yorkshire Dales	SD743733
Loven Scars, Mallerstang	NY797002
Melmerby, Coverdale	SE074857
Middle Tongue Quarry, Bewerley, Nidderdale	SE148639
Midgeley Wood, Baildon, West Yorkshire	SE142386
Millstone Band, North Stainmore	NY848173
Millstone Edge, Withnell, Lancashire	SD640213
Millstone Howe, South Stainmore	NY8511
Millstone Lumps, Addingham, Wharfeddale	SE072472
Millstones, Birkdale, Yorkshire Dales	NY830037
Moulds Top, Arkengarthdale	NY987026
Mousegill Quarry, South Stainmore, Cumbria	NY858115
Nine Standards Rigg , Mallerstang	NY825506
Penhill, Wensleydale	SE04868
Penrith Fell, Cumbria	NY5231
Pen-y-ghent Side, Yorkshire Dales	SD838746
Rylstone Fell, Upper Wharfedale	SD983577
Summer Lodge Moor, Swaledale	SD966949
Wan Fell, Great Salkeld, Cumbria	NY533352
Wasset Fell, Bishopdale	SD990830
West Dow Crag, North Stainmore	NY836518
Whelp Stone Crag, Bowland, Lancashire	SD761593
Whinfell, Brougham, Cumbria	NY5727
Whittle-le-Woods, Lancashire	SD585217
Wild Boar Fell, Mallerstang, Cumbria	SD760985
Woodhall Greets, Wensleydale	SD968923

Acknowledgements

I am grateful to Carol and Alan Dougherty, who accompanied me on many field explorations; to the late Miles Newman for his company while surveying sites in Mallerstang; and to my partner Alison who shared my enthusiasm for millstone workings and provided geological expertise. I acknowledge the assistance of reading room staff in various county record offices, The National Archives and the British Library. Annie Hamilton-Gibney first drew my attention to the workings in Mallerstang, the late Phil Hudson to those on Clougha, and Peter Gallagher to those on Embsay Moor.

All unattributed photographs were taken by the author. Every effort has been made to contact copyright holders of archival images used in this book. If you believe you have been overlooked, please contact the publisher. If anyone whose name should have been mentioned has been omitted, apologies are offered.

Space restrictions preclude the inclusion of distribution maps of all sites mentioned in the text, but to aid identification all have been given a national grid reference in the list of Surveyed Production Sites at the end of the book. Specialist terms are italicised in the text. The red and white ranging poles seen in many of the photographs are 1 m long. The smaller scale seen in some images is 200 mm.